DRAW 100 MANGA

from basic shapes to amazing
drawings in super-easy steps

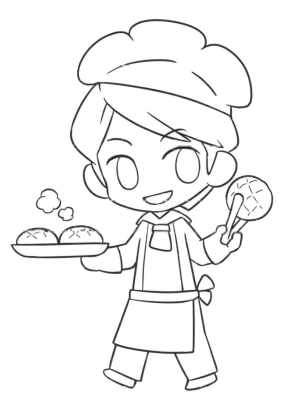

Yishan li

SEARCH PRESS

First published in 2023

Search Press Limited
Wellwood, North Farm Road,
Tunbridge Wells, Kent TN2 3DR

Draw 100: Manga combines new
material with some also published in
How to Draw Manga Heroes and *How to
Draw Manga Faces*, also by Yishan Li

Text copyright © Search Press Ltd., 2023

Design and illustrations copyright ©
Search Press Ltd. 2023

ISBN: 978-1-80092-114-6
ebook ISBN: 978-1-80093-101-5

CONTENTS

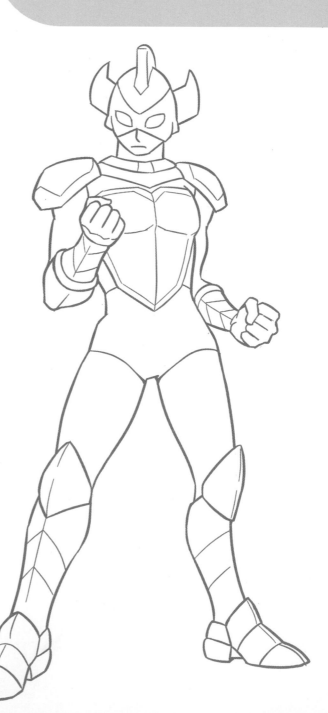

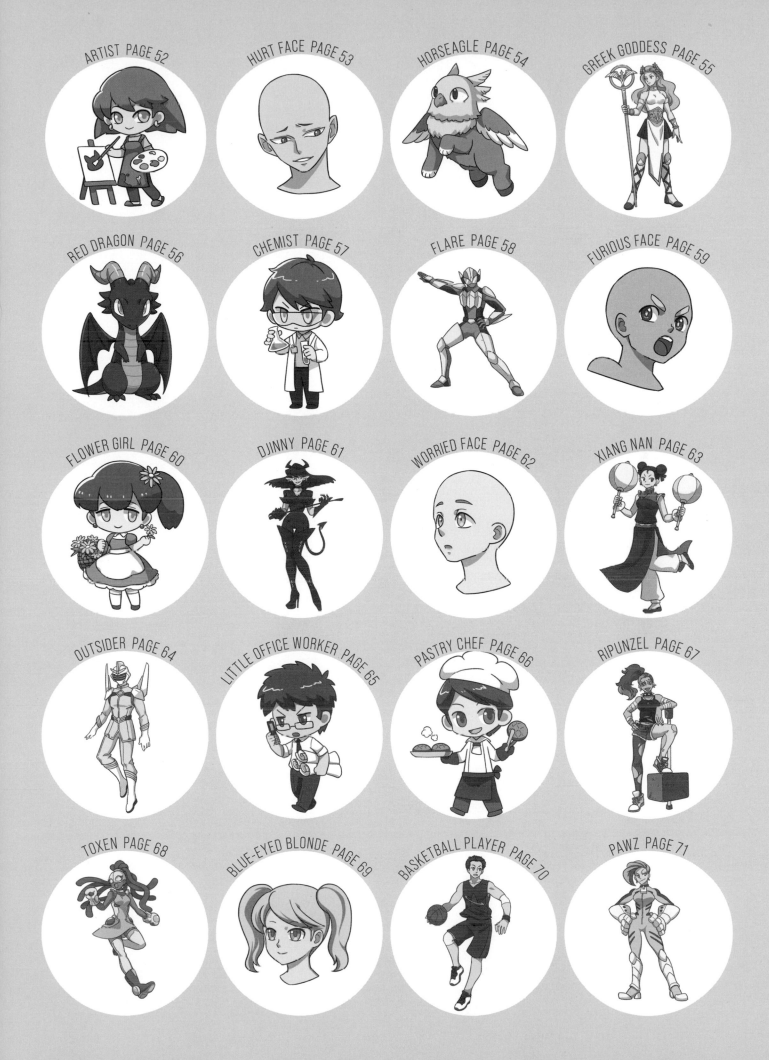

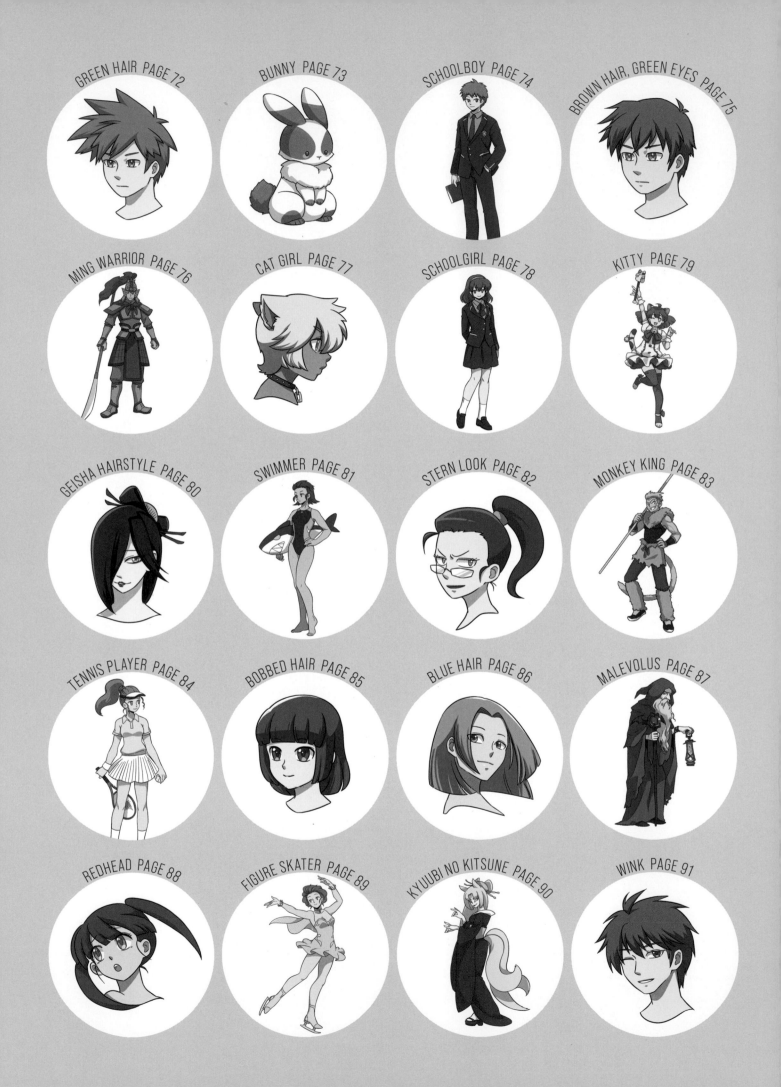

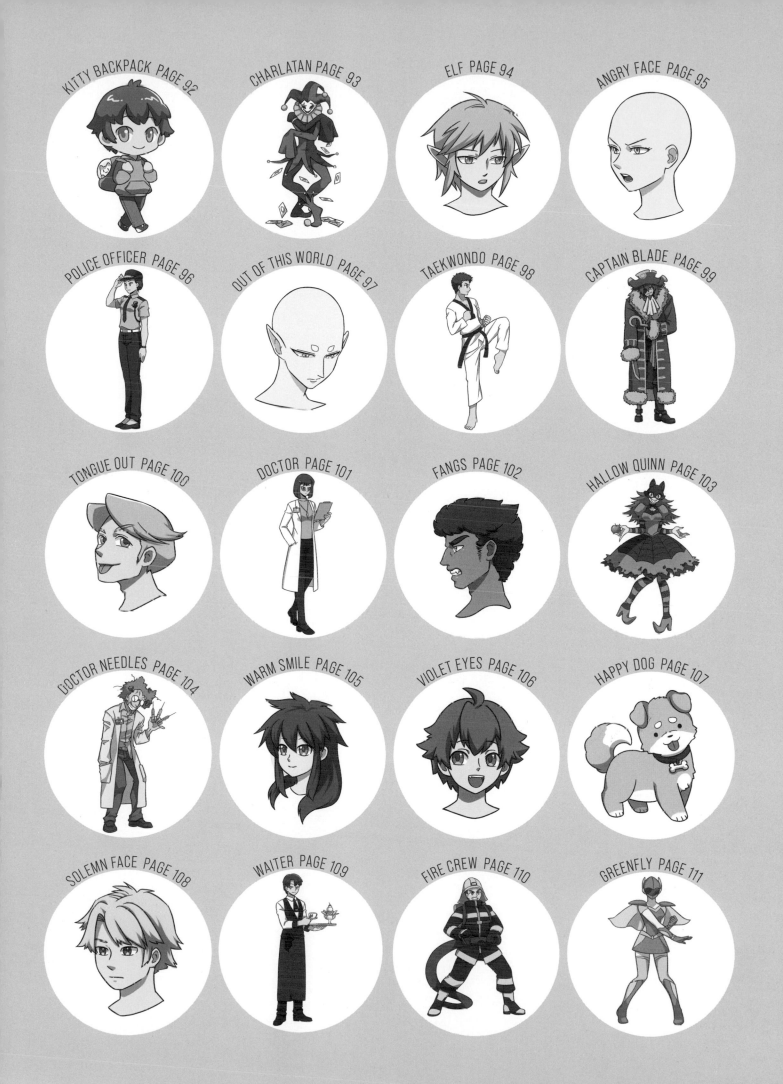

KITTY BACKPACK PAGE 92

CHARLATAN PAGE 93

ELF PAGE 94

ANGRY FACE PAGE 95

POLICE OFFICER PAGE 96

OUT OF THIS WORLD PAGE 97

TAEKWONDO PAGE 98

CAPTAIN BLADE PAGE 99

TONGUE OUT PAGE 100

DOCTOR PAGE 101

FANGS PAGE 102

HALLOW QUINN PAGE 103

DOCTOR NEEDLES PAGE 104

WARM SMILE PAGE 105

VIOLET EYES PAGE 106

HAPPY DOG PAGE 107

SOLEMN FACE PAGE 108

WAITER PAGE 109

FIRE CREW PAGE 110

GREENFLY PAGE 111

INTRODUCTION

The term 'manga' is a Japanese word meaning comics or cartoons. Manga originated in Japan and has become super popular all around the world in the past few decades. Artists from many countries are now drawing in manga-influenced styles.

You have probably seen manga drawings before and liked them – that's why you picked up this book, right? The good news is that learning to draw manga is not that hard. Most aspiring manga artists learn by trying to trace or replicate their favourite characters first, and you should do the same. However, when you first pick up the pencil, you probably won't know where to start. Should you draw the eyes first? Where should you put the eyebrows? How do you avoid making your character look unbalanced?

That's why I have created this book. With my step-by-step drawings, you will learn how to draw manga by starting with simple shapes, then building up to a complete image. You can pick something simple to start with, like an eye or mouth, then draw a whole face, then a whole character! Or if you prefer non-human characters, you can pick a cat, a bird or Octomushroom! There are a hundred drawings in this book so there is a healthy mix of everything you could want to draw.

The number one rule of drawing is that the more you practise, the better you will get. Draw whenever you can and enjoy creating your own manga world!

WHAT DO YOU NEED?

To begin any drawing, you'll require some equipment.

- **Pencil** You can choose any soft graphite pencil, preferably a 2B.

- **Paper** I prefer normal copying paper to special art paper because it's cheaper and easy to draw on.

- **Eraser** Once you have inked in your drawing with a non-smudging pen, you will need to rub out all your pencil marks. Use the one you normally use at home or in school.

- **Tracing paper** If you'd like to practise drawing the shapes before committing them to paper, you could begin by tracing the drawings in this book on to tracing paper.

- **Black waterproof gel pen** Try this first on a spare piece of paper to make sure it doesn't smudge. This means that you can rub out all the pencil lines with the eraser without smudging the outlines.

- **Water-based dye ink pens** I use these for colouring the final images but, if you prefer, you can use colouring materials you already have at home.

- **Coloured pencils** If you don't have water-based dye ink pens, you can colour your images with your favourite coloured pencils.

- **Watercolour pencils** Similarly, you can use watercolour pencils to colour in the final drawings. Note that if you are going to add water, you will need to use smooth watercolour paper instead of copying paper.

HOW TO USE THIS BOOK

First of all, choose a manga drawing from the contents list at the start of the book. Next find the step-by-step stages that show you how to draw it, gather together your paper, pencil and eraser and you're ready to start!

The first stage of every drawing consists of simple shapes or outlines. Copy these, then move on to the next stage and add a bit more detail. Each new stage is shown in a second colour so that it stands out from the parts you have already drawn. Continue in this way and, in up to eight easy steps, you will have a beautiful finished drawing ready to colour. I have then shown the final image coloured in inks.

When drawing the initial shapes in pencil, start with very light strokes, then add more details using slightly more solid lines. This way you can see your final image clearly rather than burying it in all the messy lines. Once you are more confident with your pencil drawings, you can start to add ink. The ink pen can be any black waterproof gel pen. Try it first on a spare piece of paper to make sure it doesn't smudge. Draw over your final outline, then erase the pencil lines.

For colouring, I use water-based dye ink pens, but if you prefer something that's easy to find at home, you can also use watercolour or coloured pencils.

The most important thing I hope you learn from this book is to be creative. You can combine the various features, heads and hair to create your own faces, or change the expressions and outfits to create your own manga characters. Some of the animals are strange combinations – why not mix and match to come up with your own manga creatures?

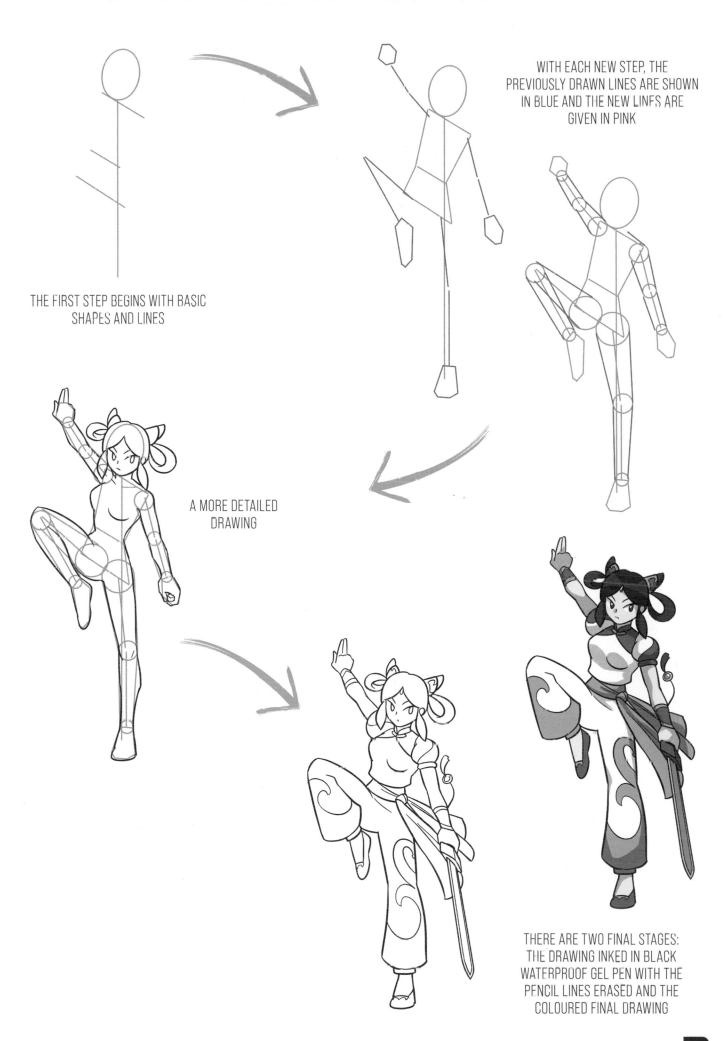

WITH EACH NEW STEP, THE PREVIOUSLY DRAWN LINES ARE SHOWN IN BLUE AND THE NEW LINES ARE GIVEN IN PINK

THE FIRST STEP BEGINS WITH BASIC SHAPES AND LINES

A MORE DETAILED DRAWING

THERE ARE TWO FINAL STAGES: THE DRAWING INKED IN BLACK WATERPROOF GEL PEN WITH THE PENCIL LINES ERASED AND THE COLOURED FINAL DRAWING

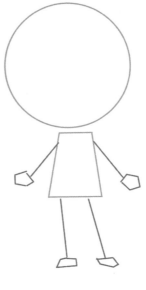
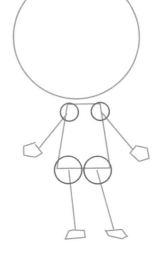
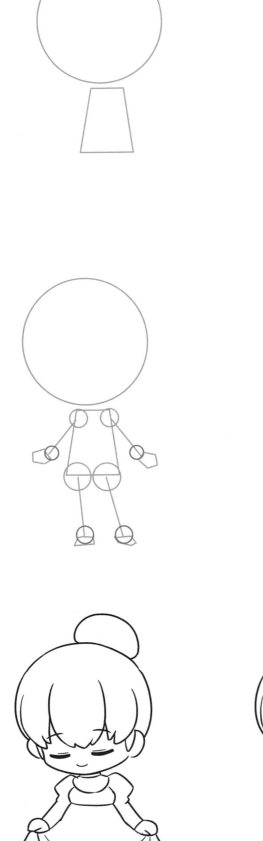

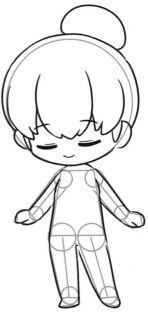
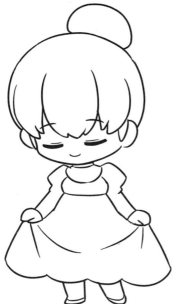
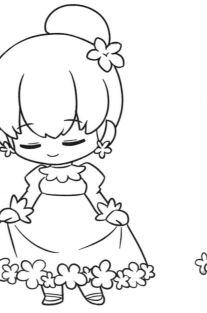
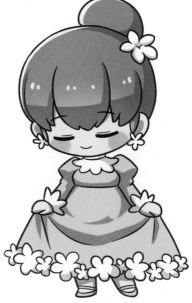

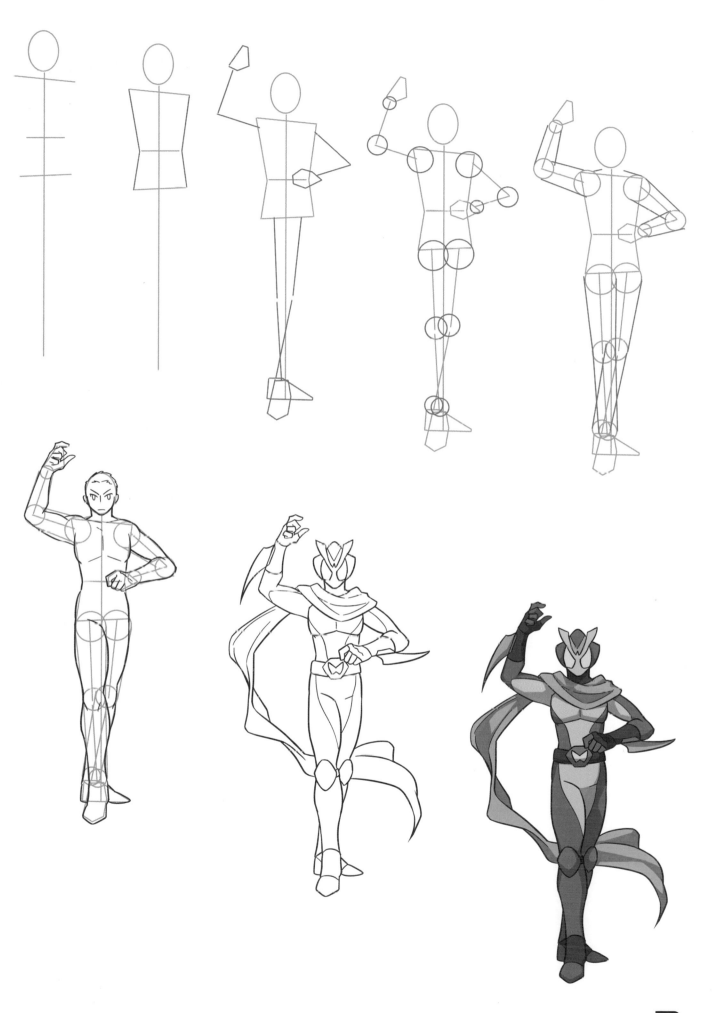

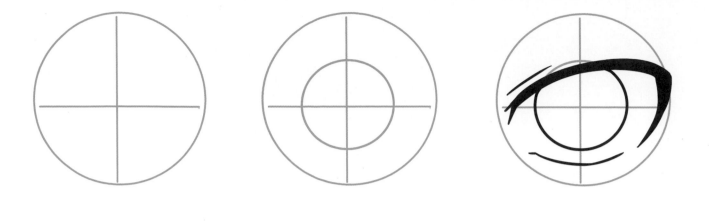

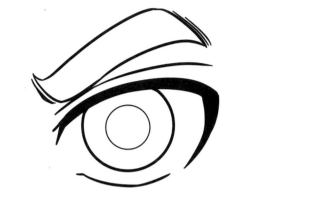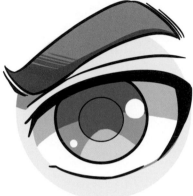

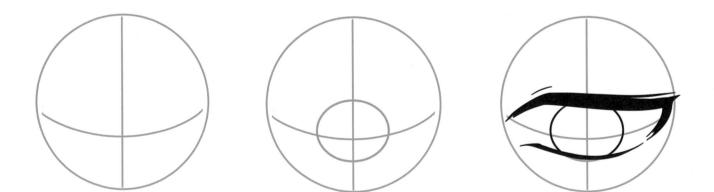

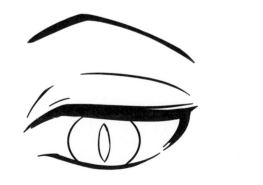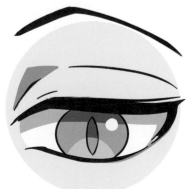

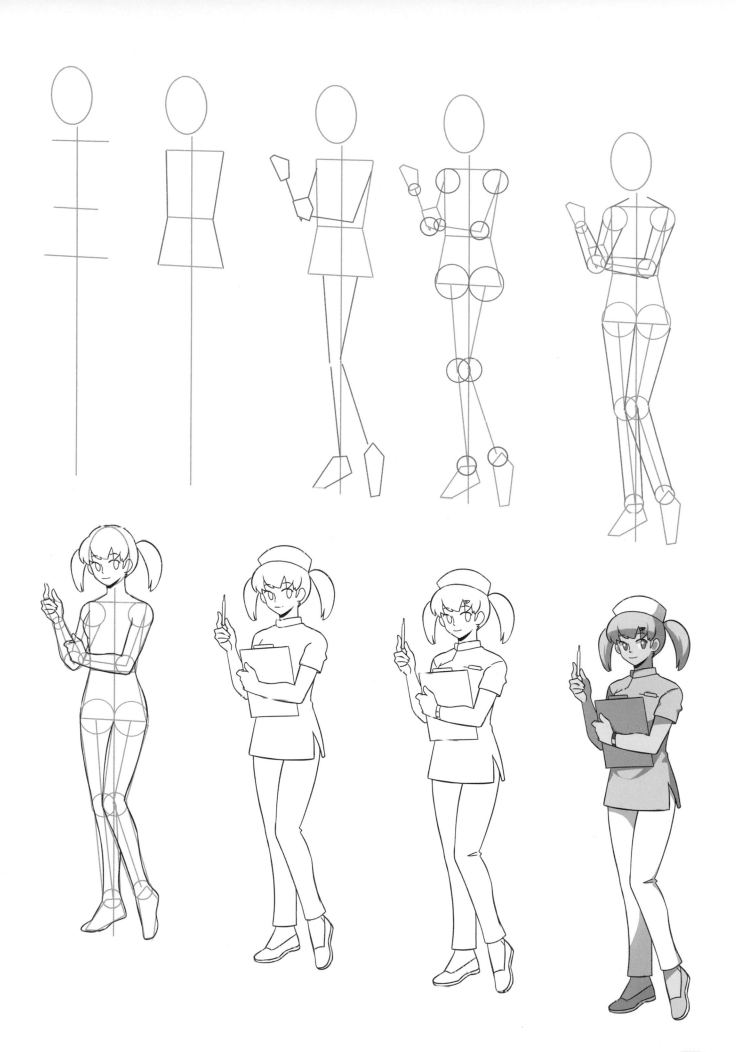

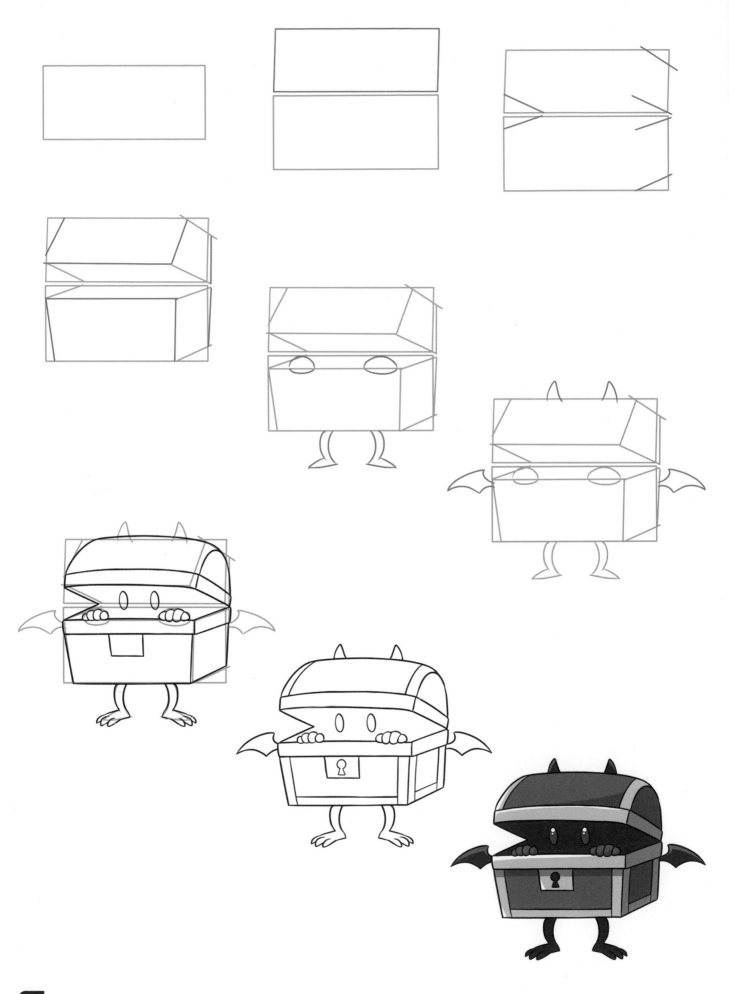

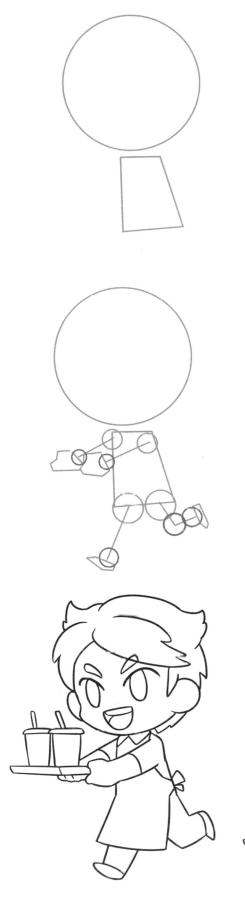
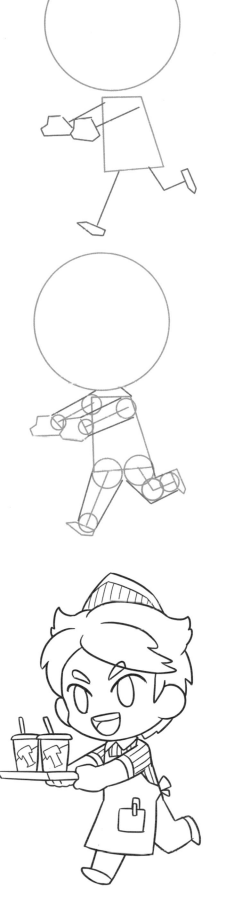
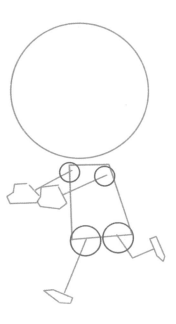
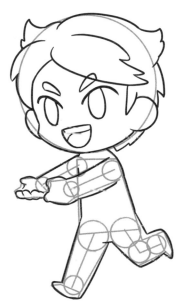
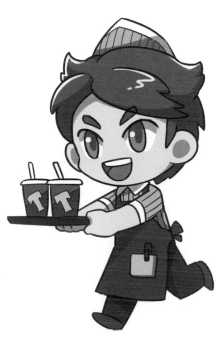

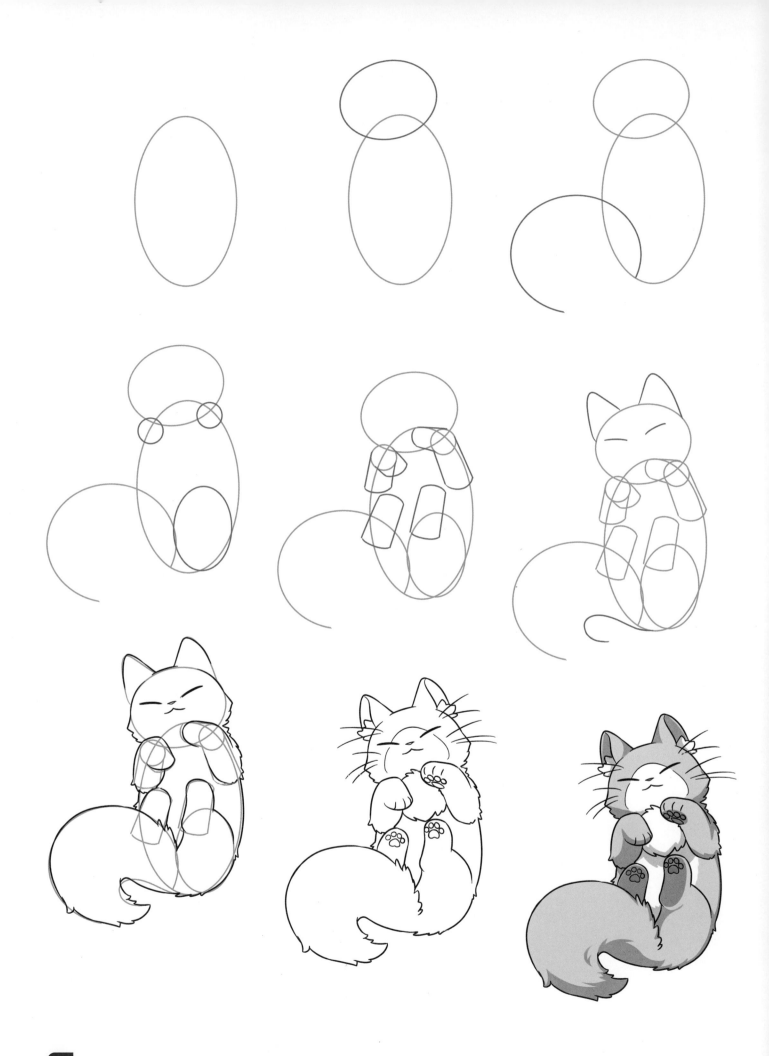

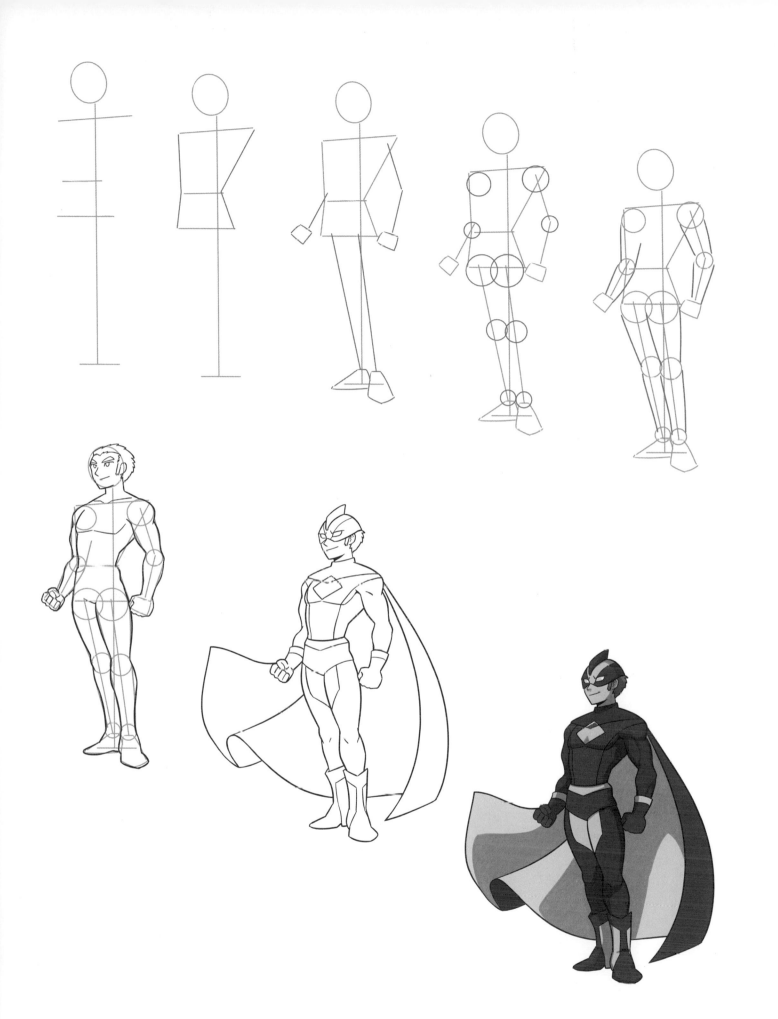

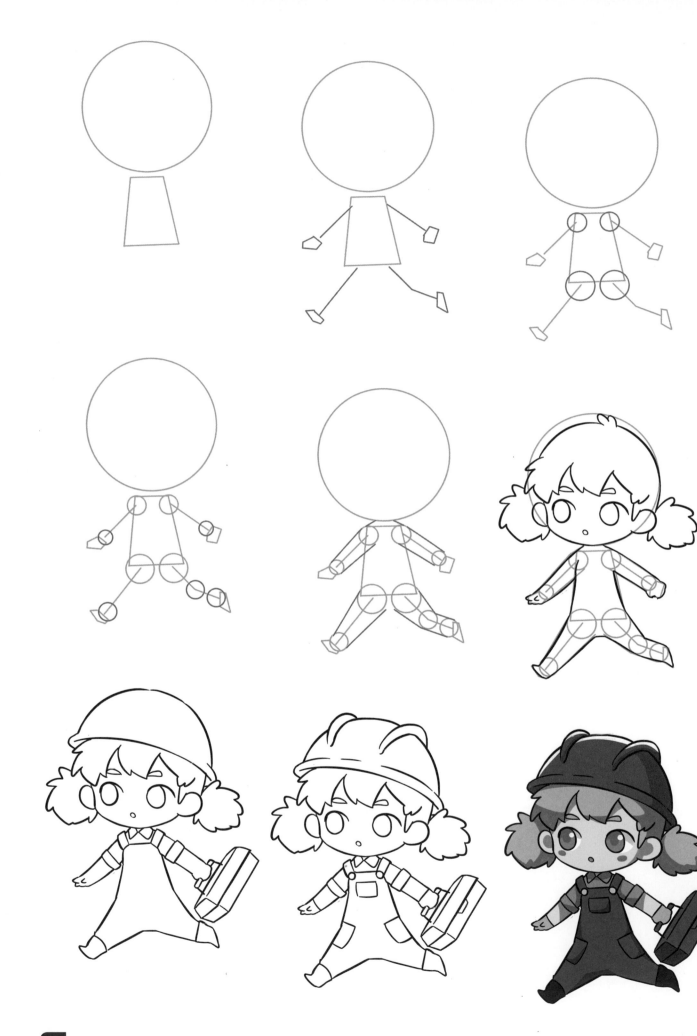

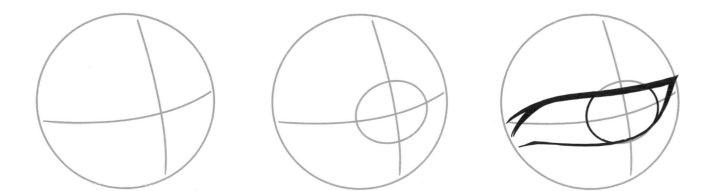

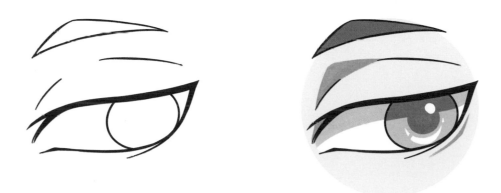

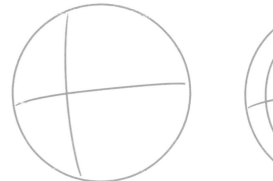

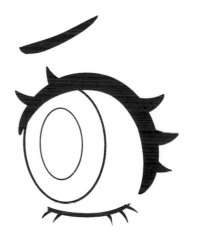
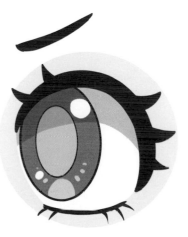

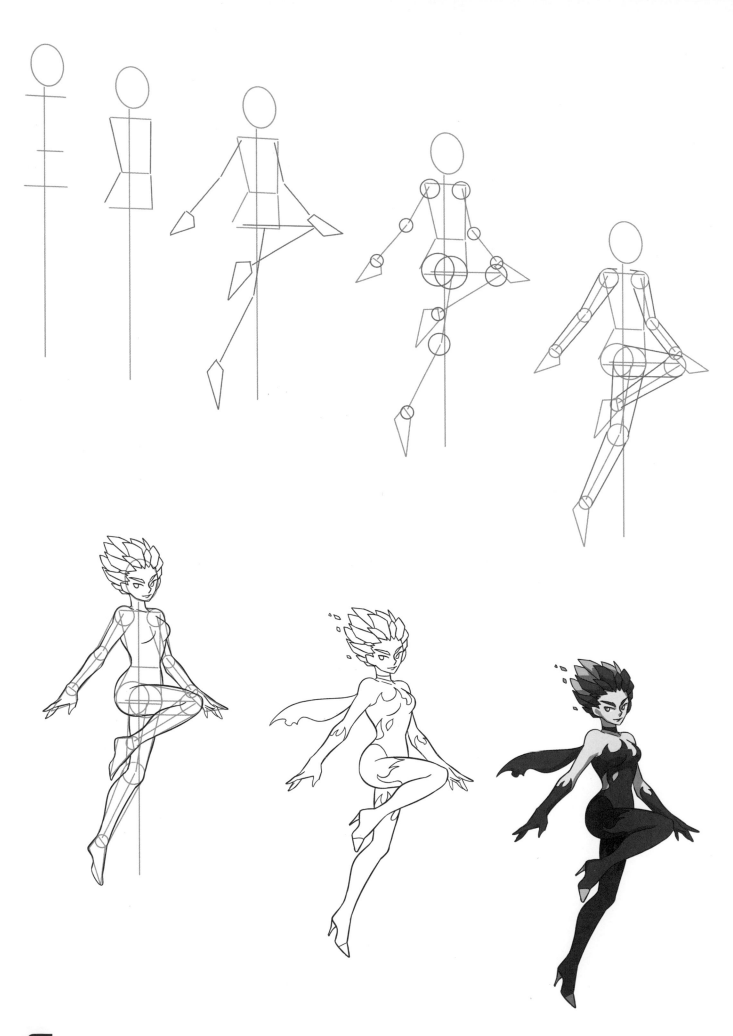

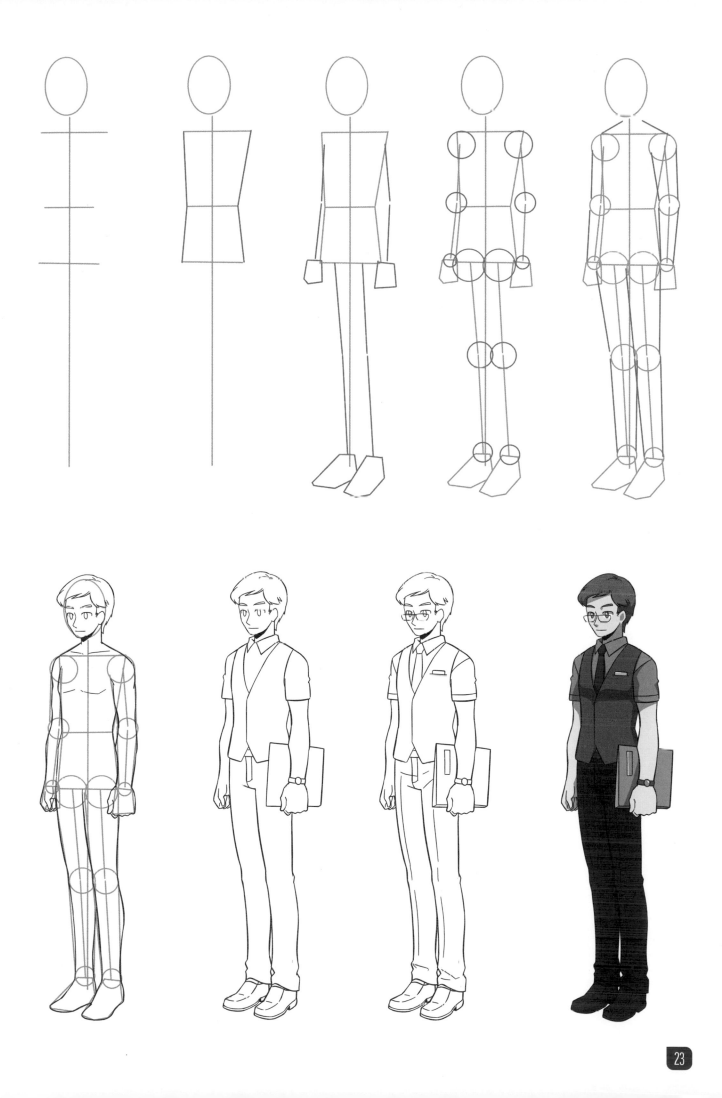

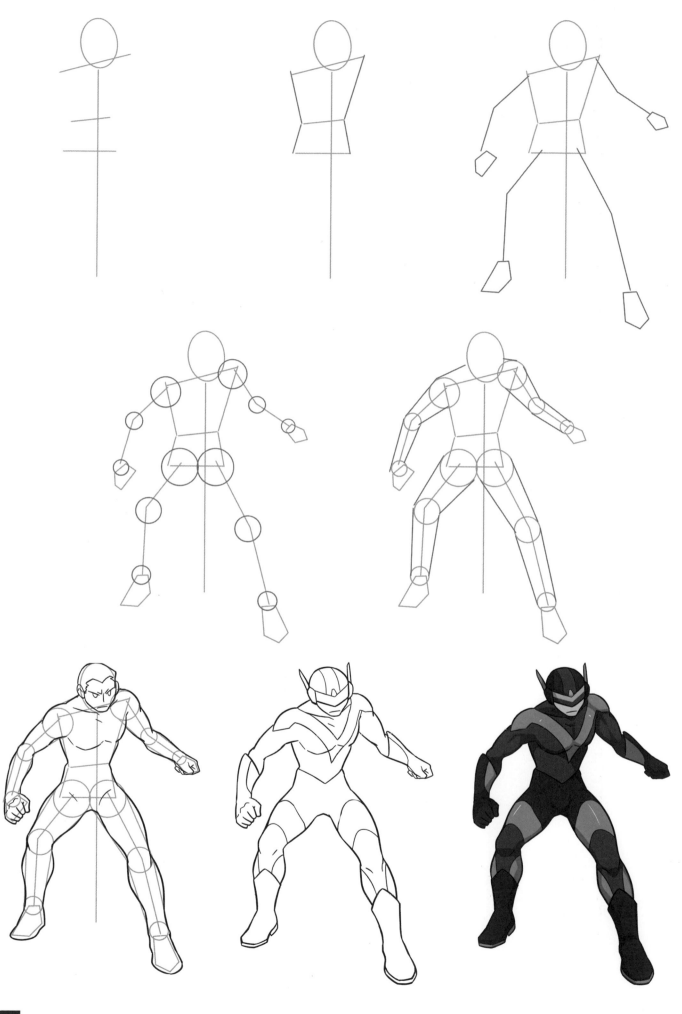

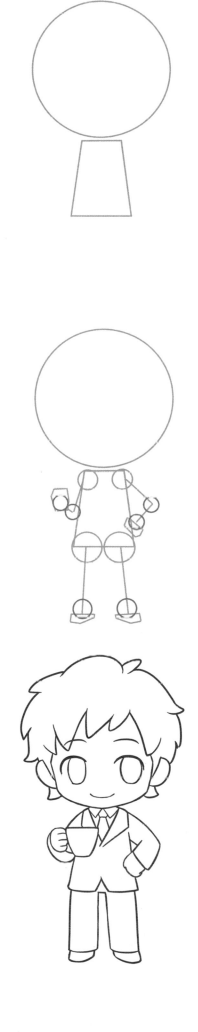

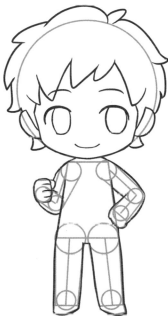
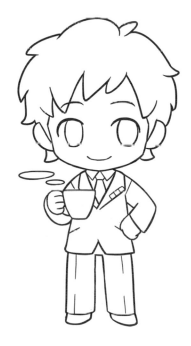
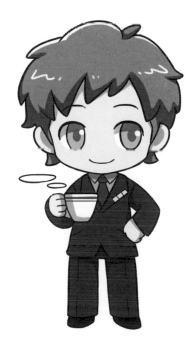

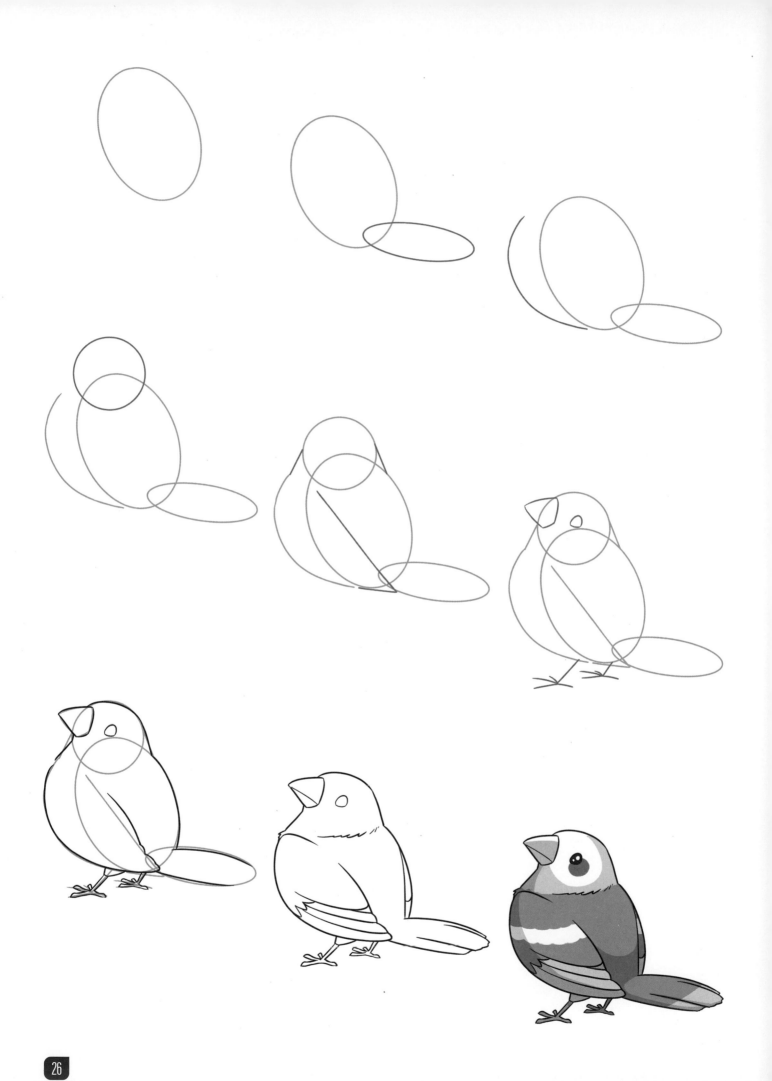

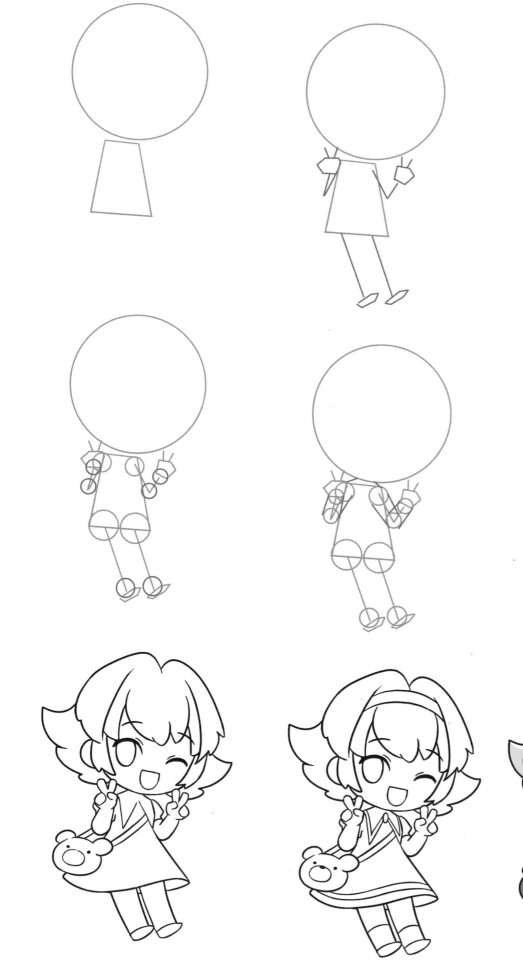
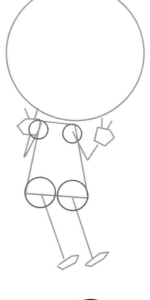
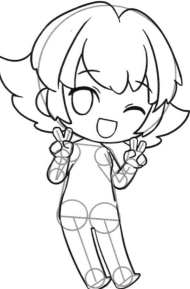
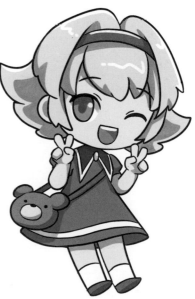

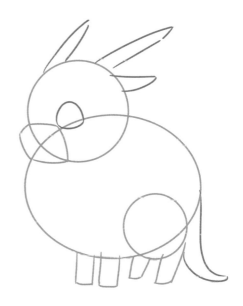
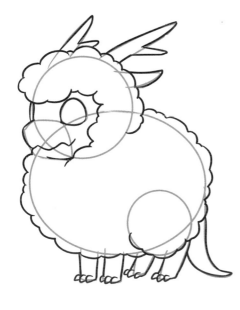
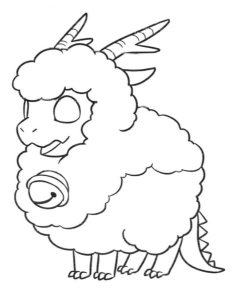
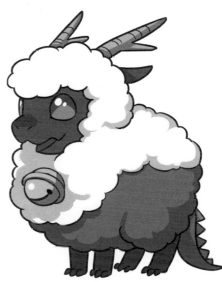

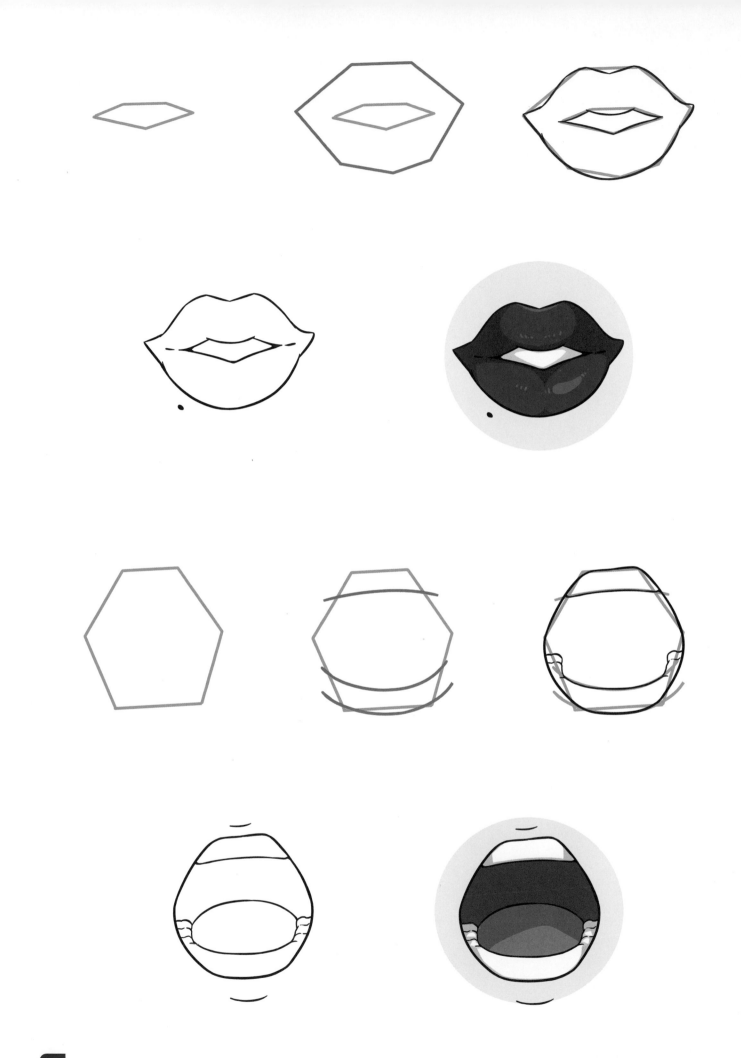

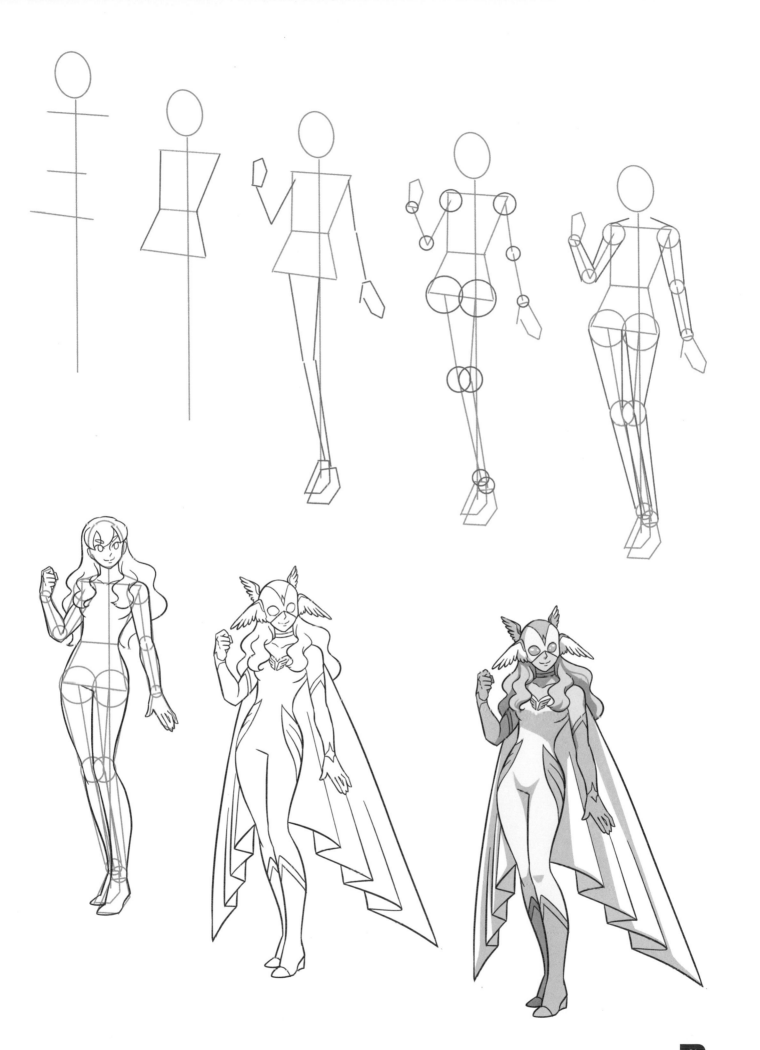

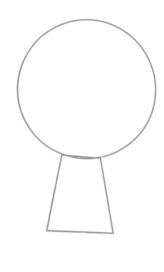
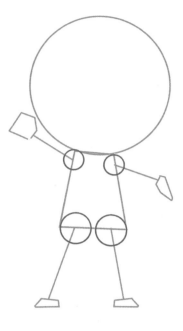
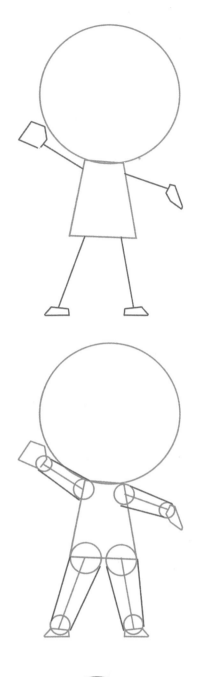
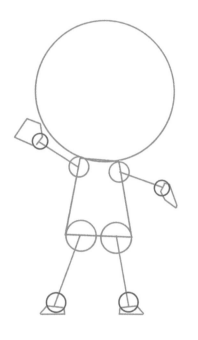
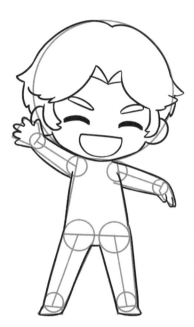
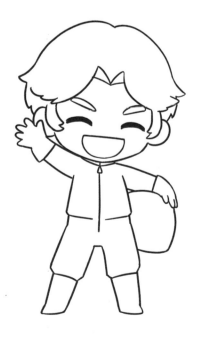
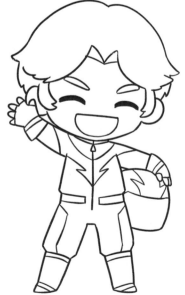
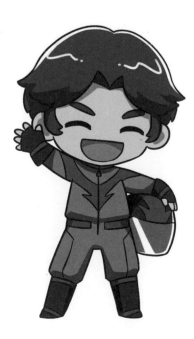

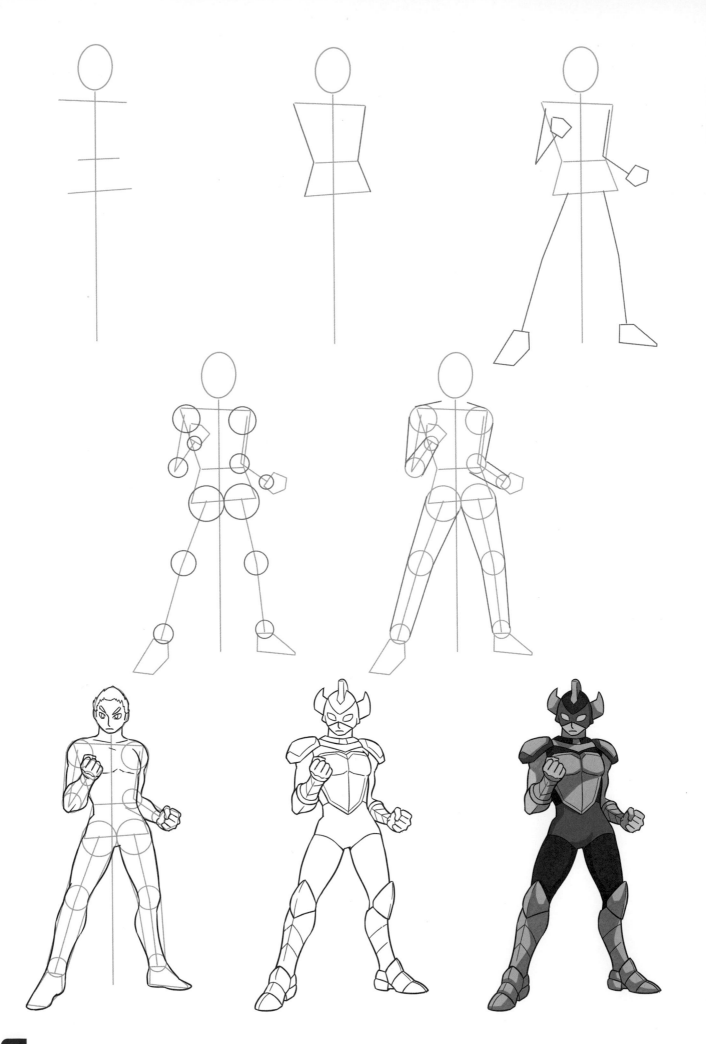

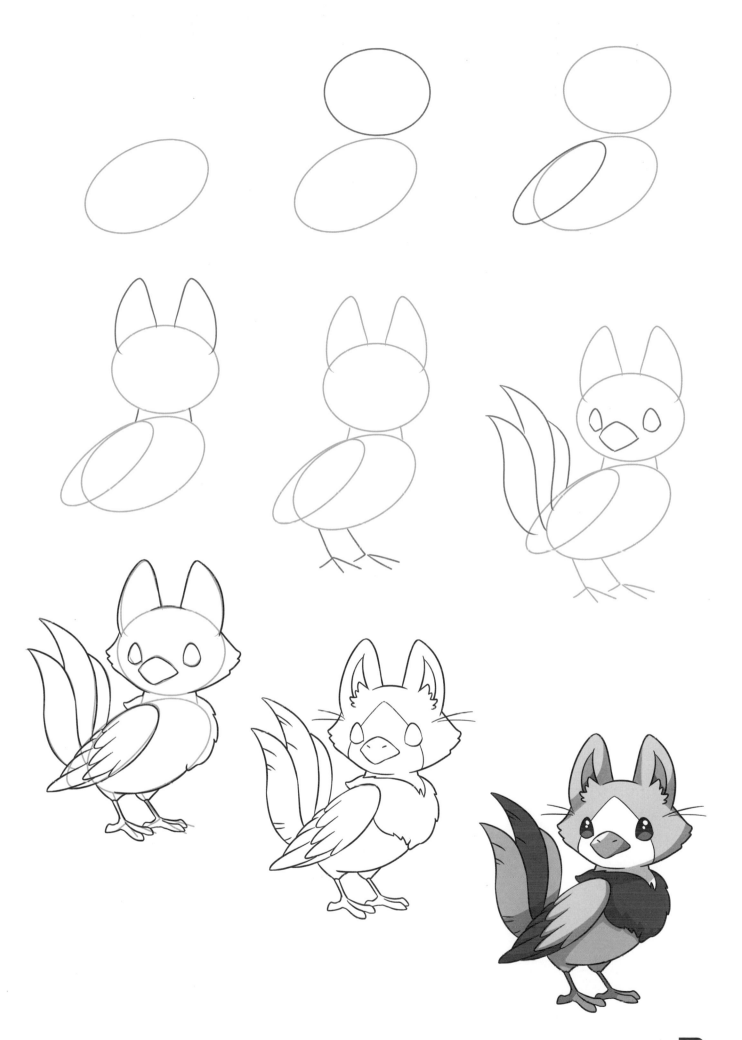

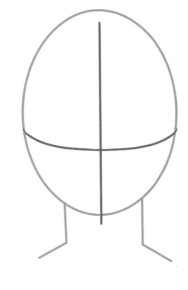
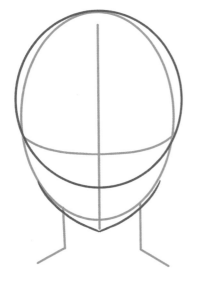
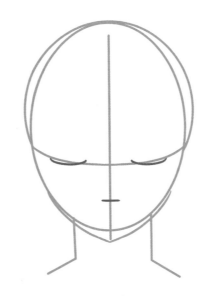
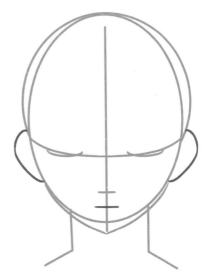

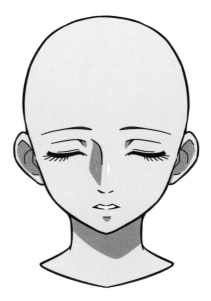

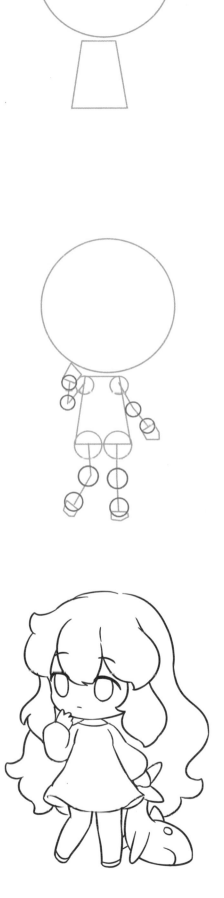
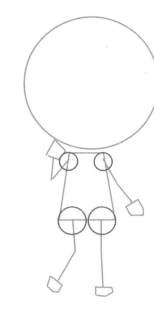

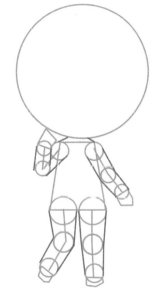
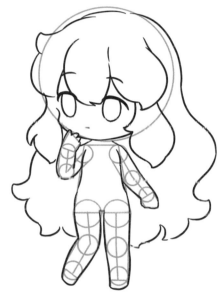
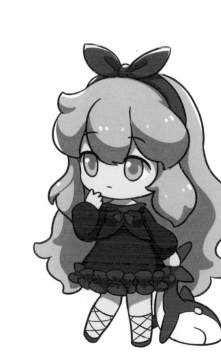

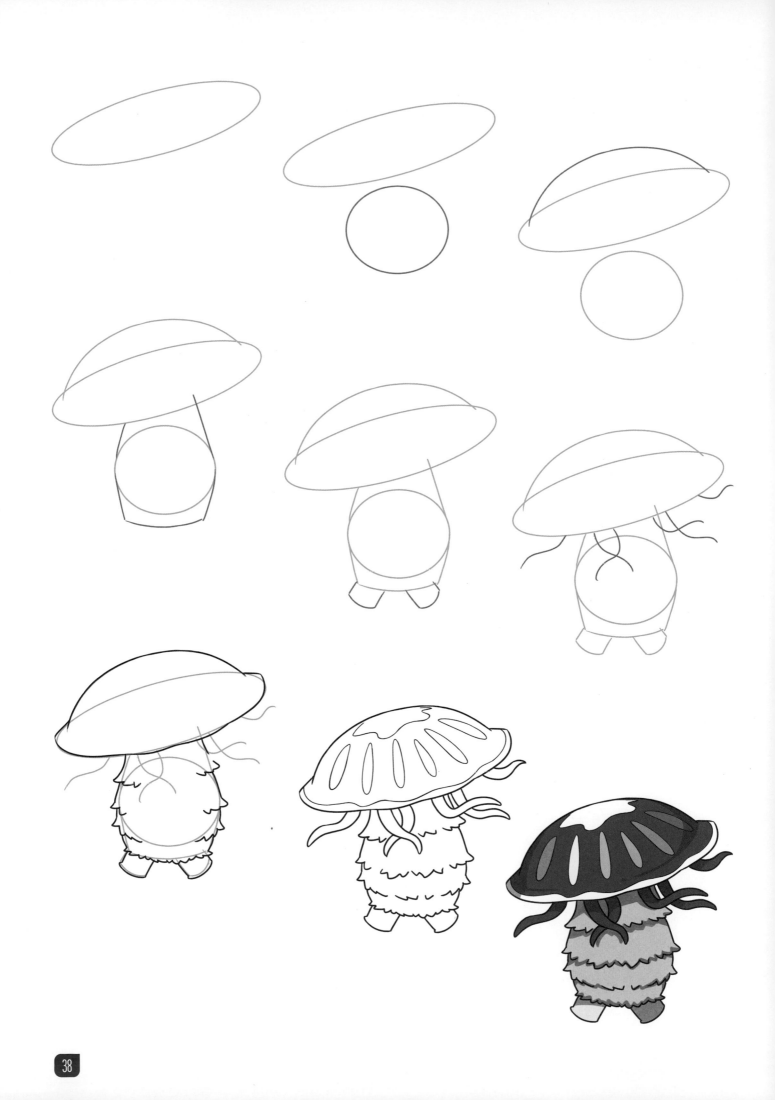

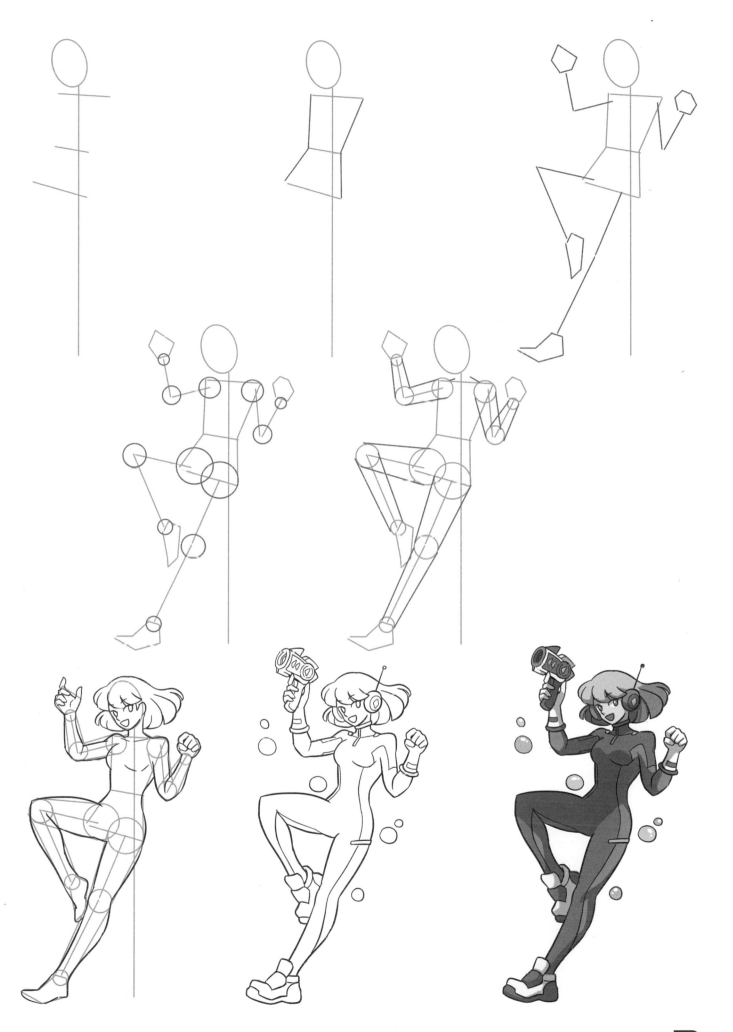

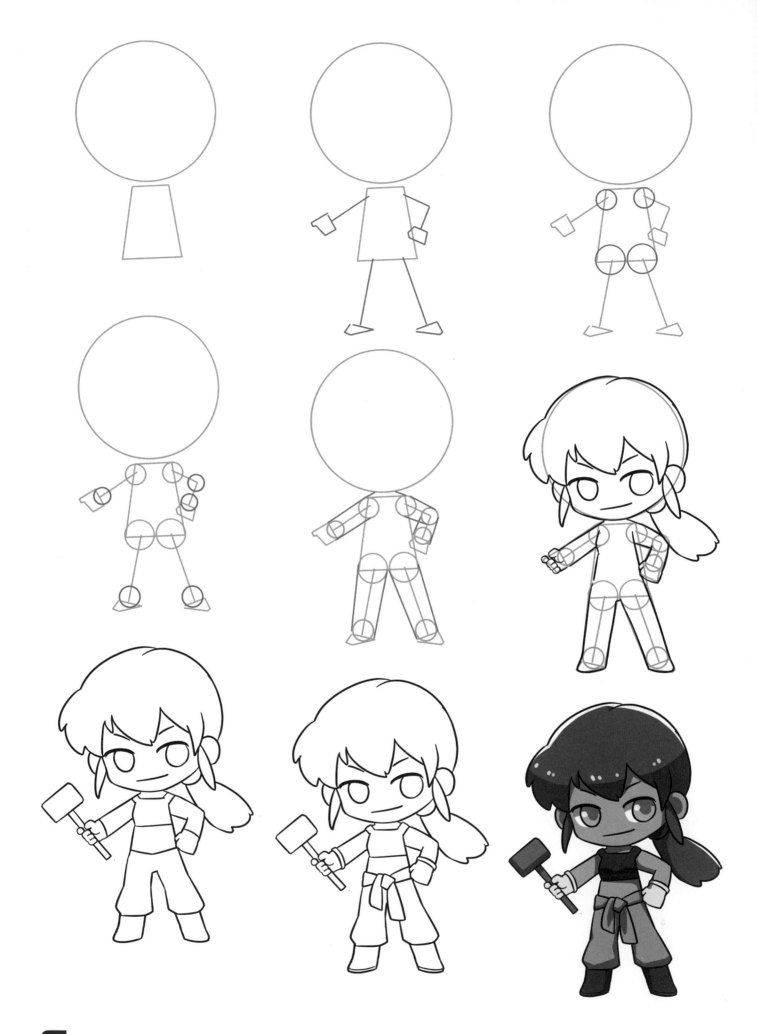

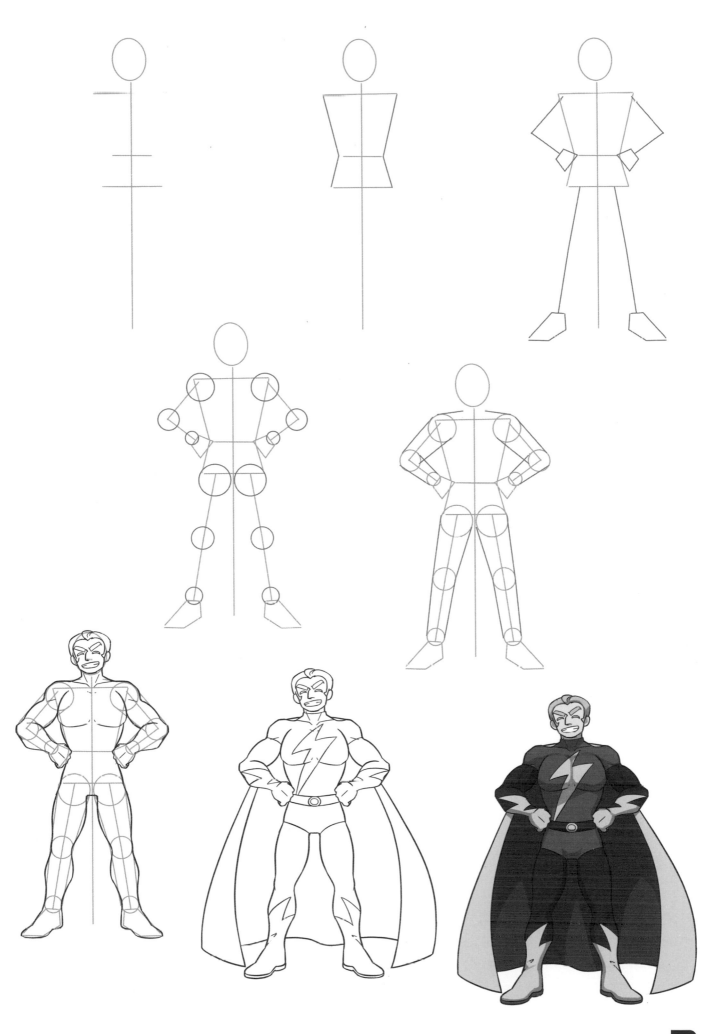

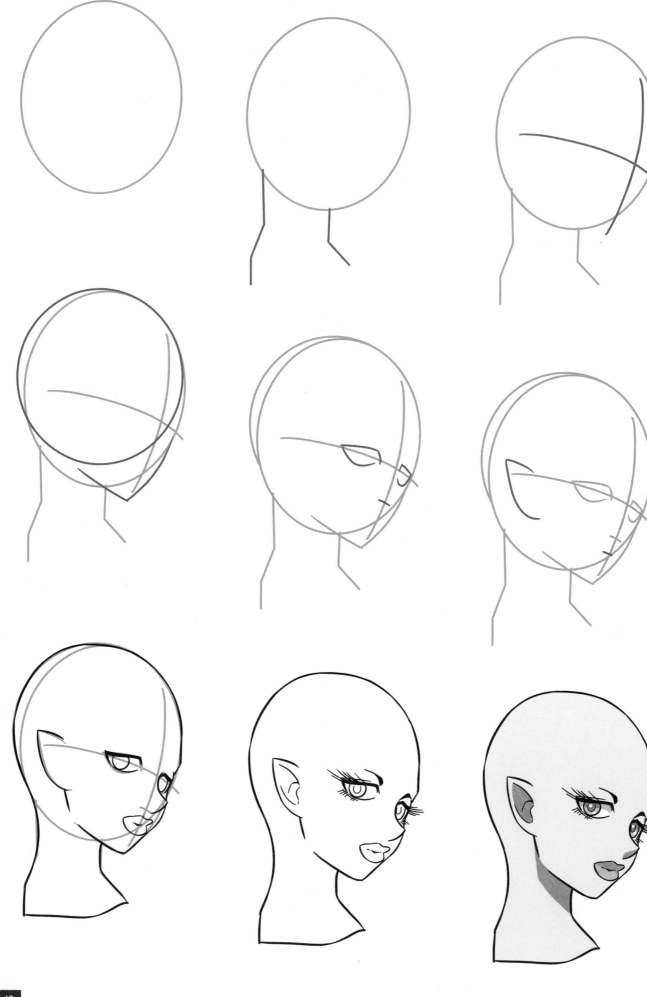

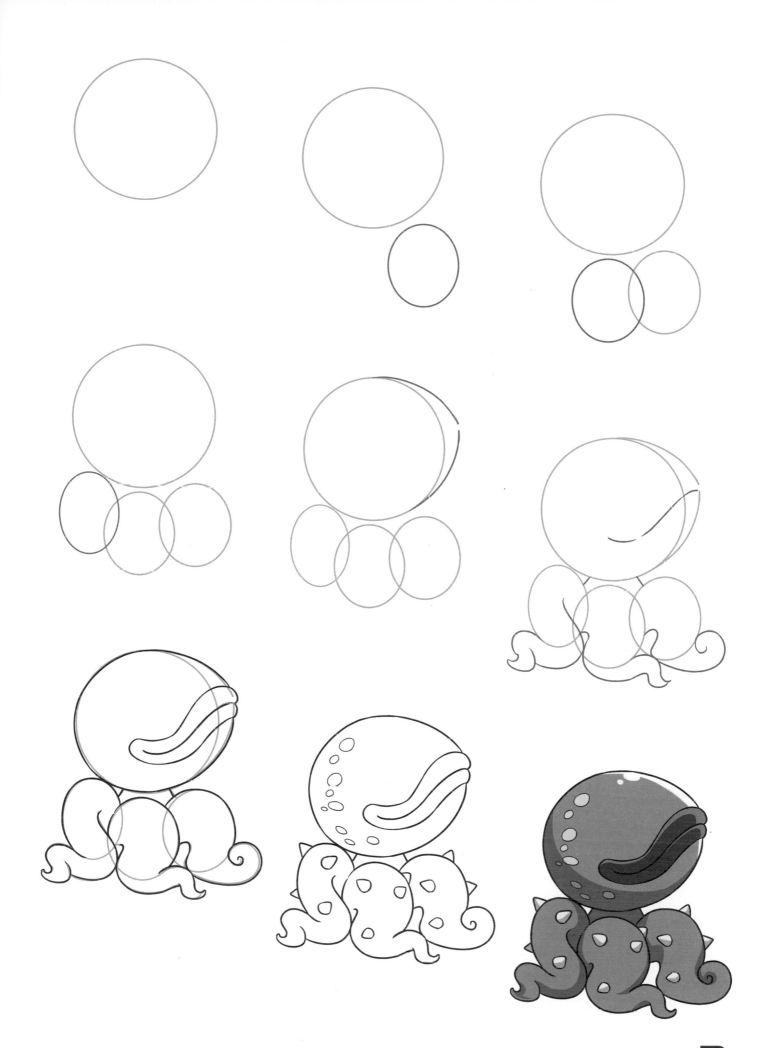

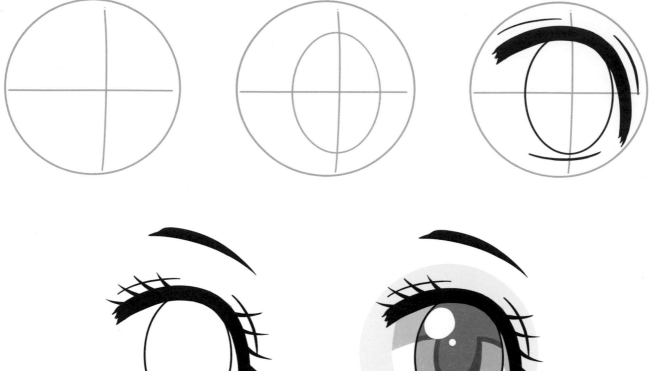

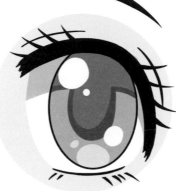
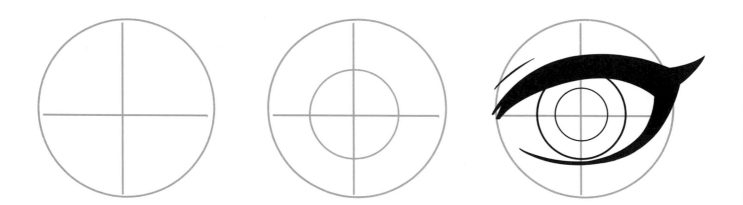
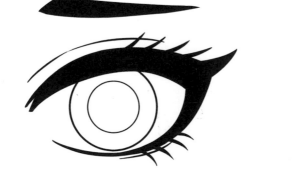
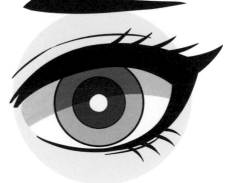

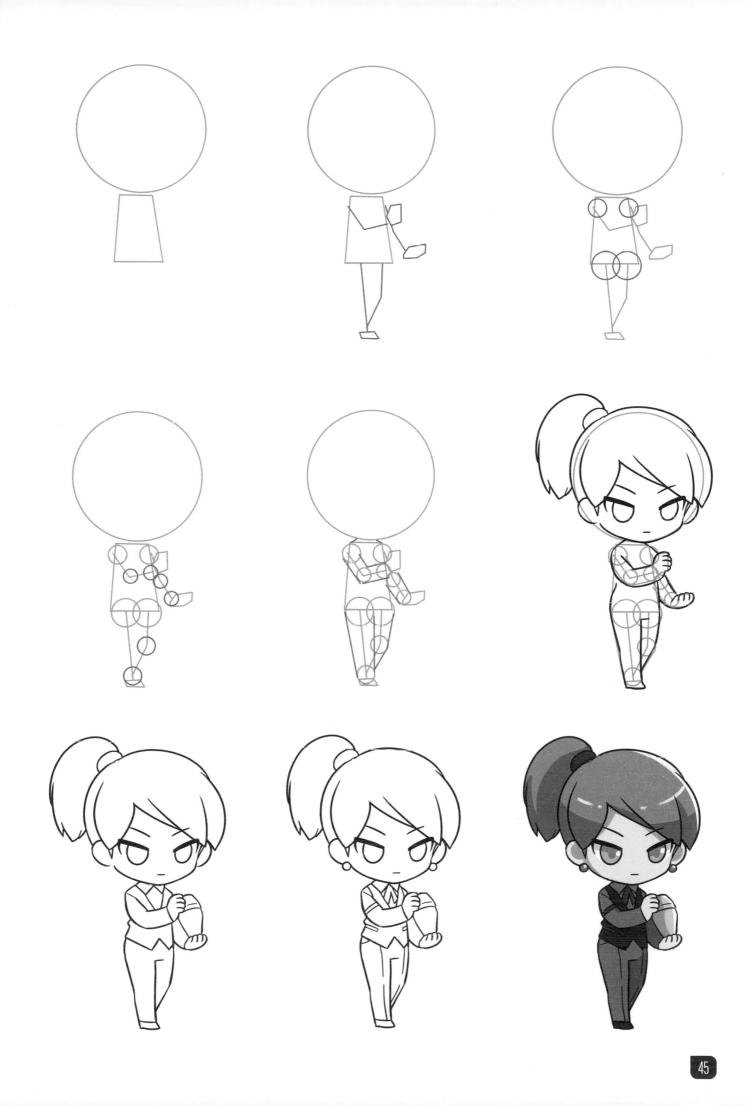

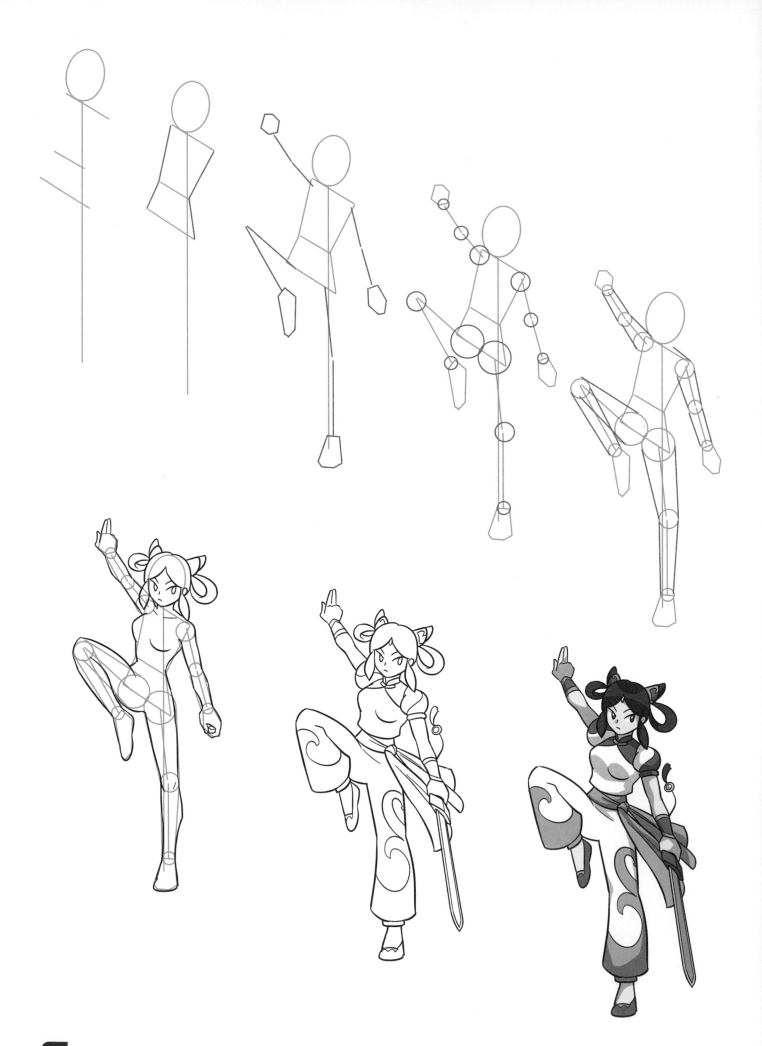

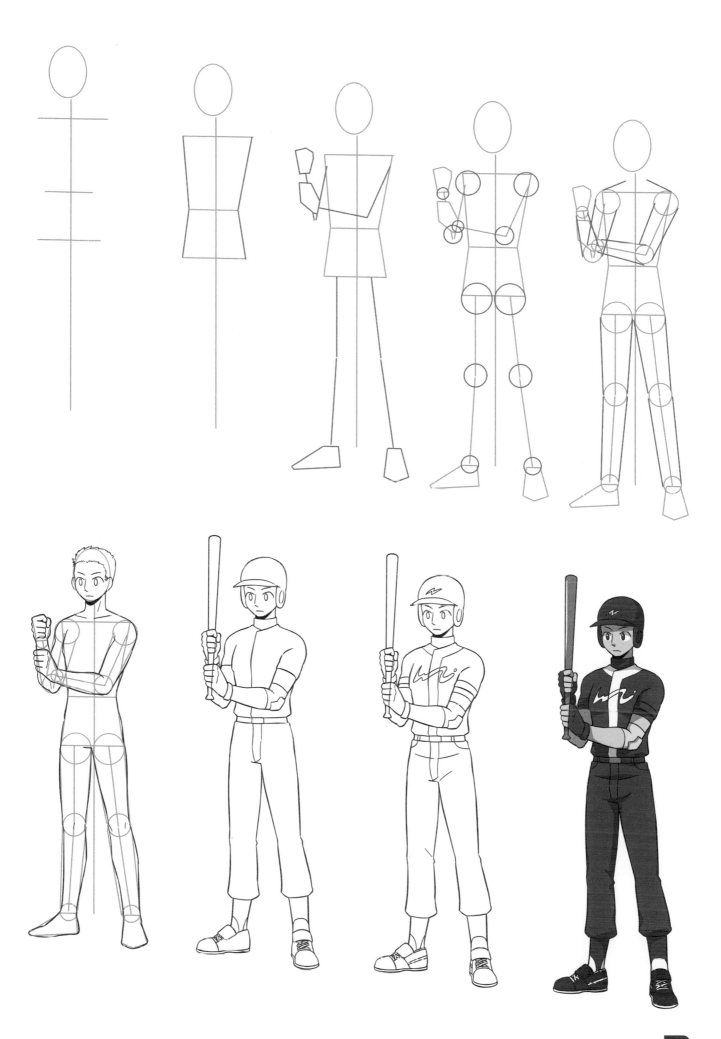

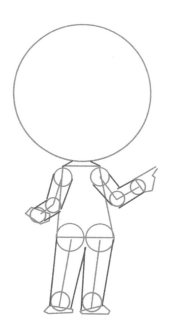
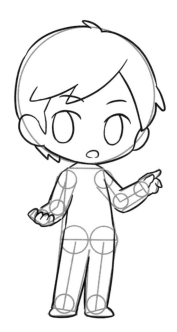
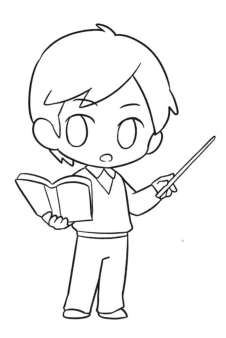
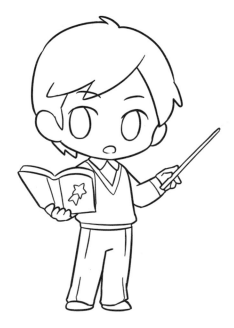
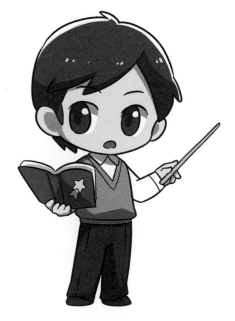

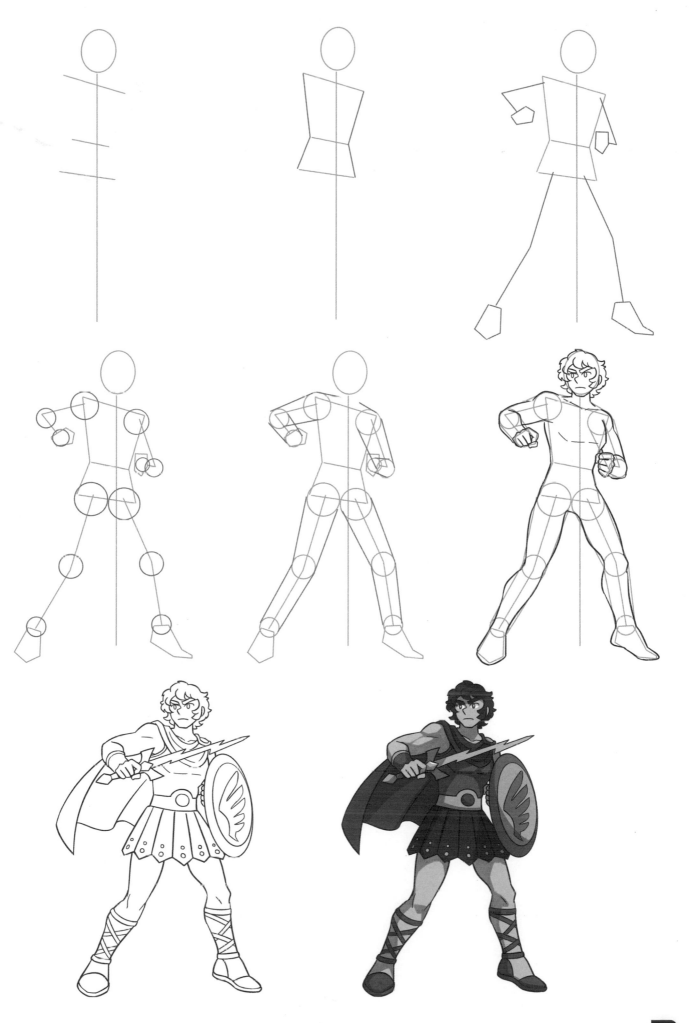

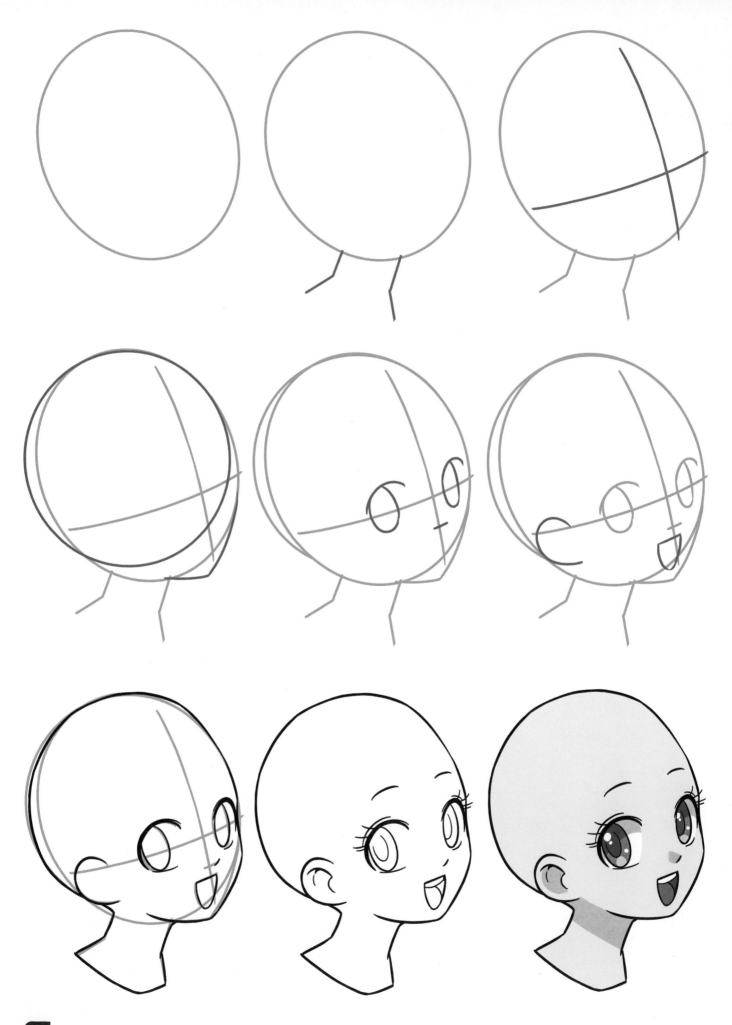

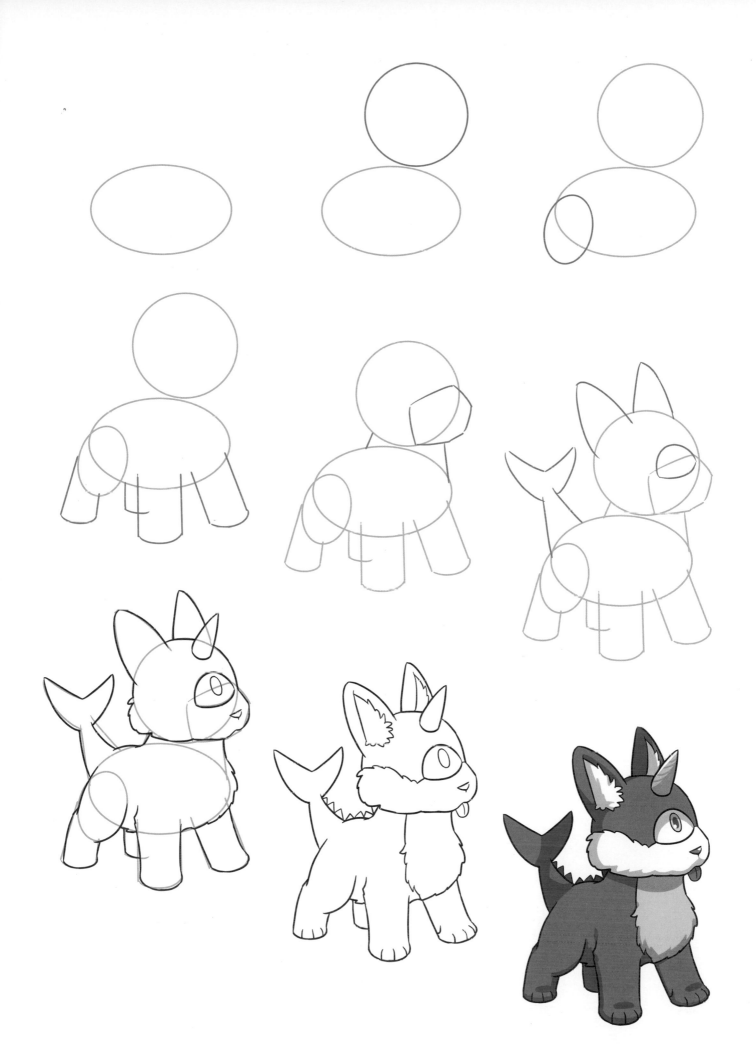

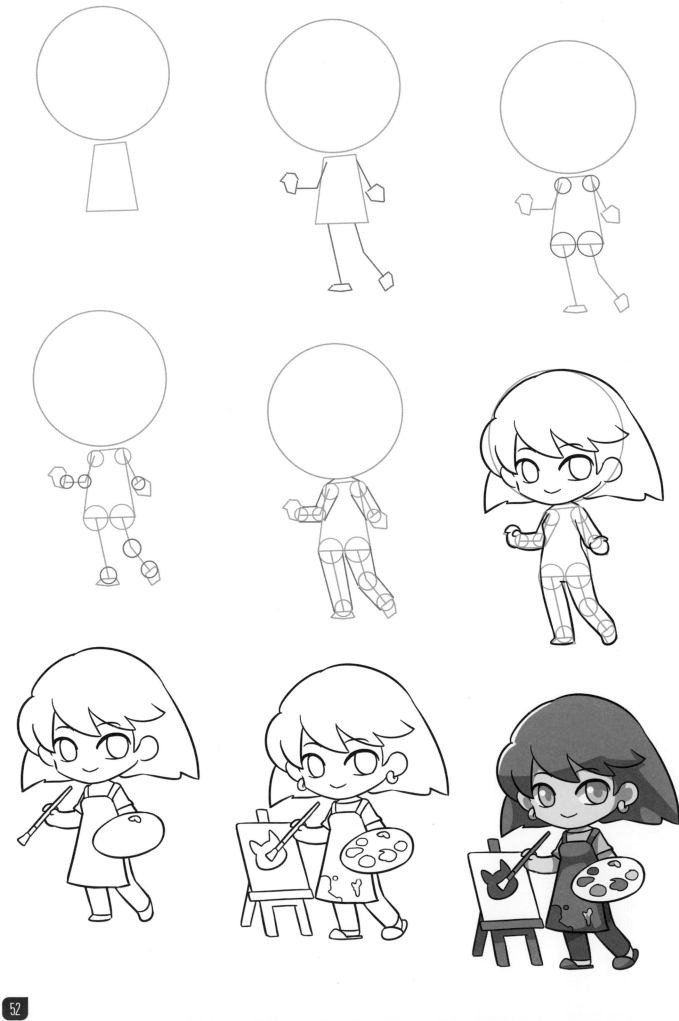

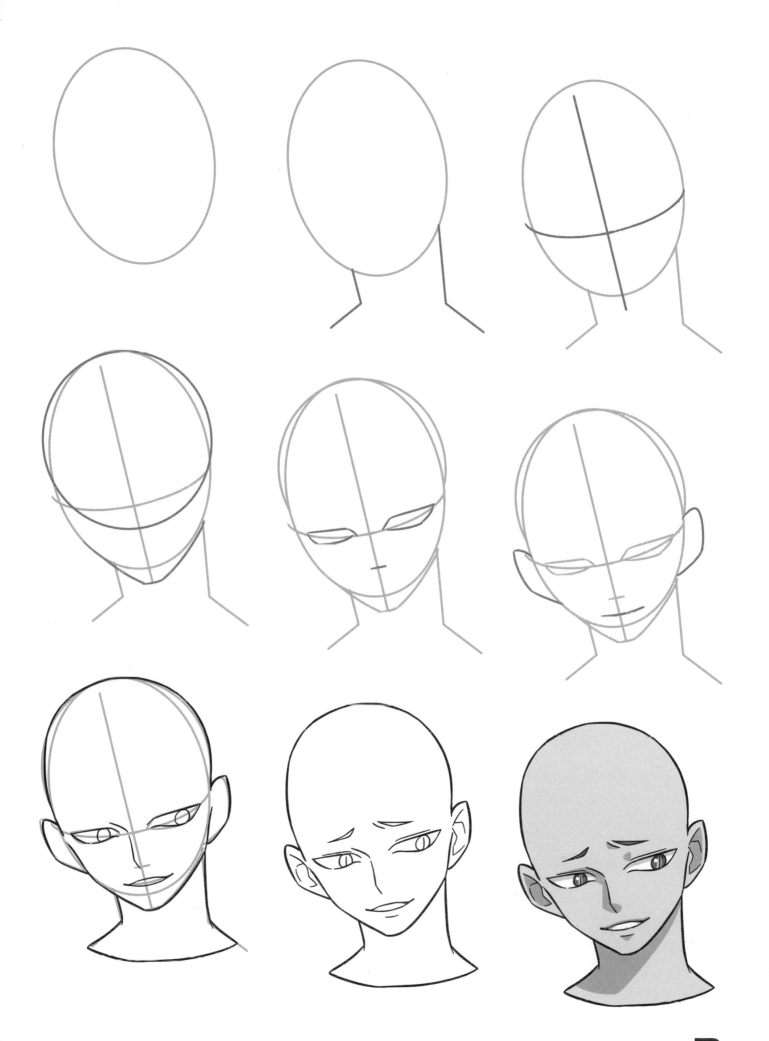

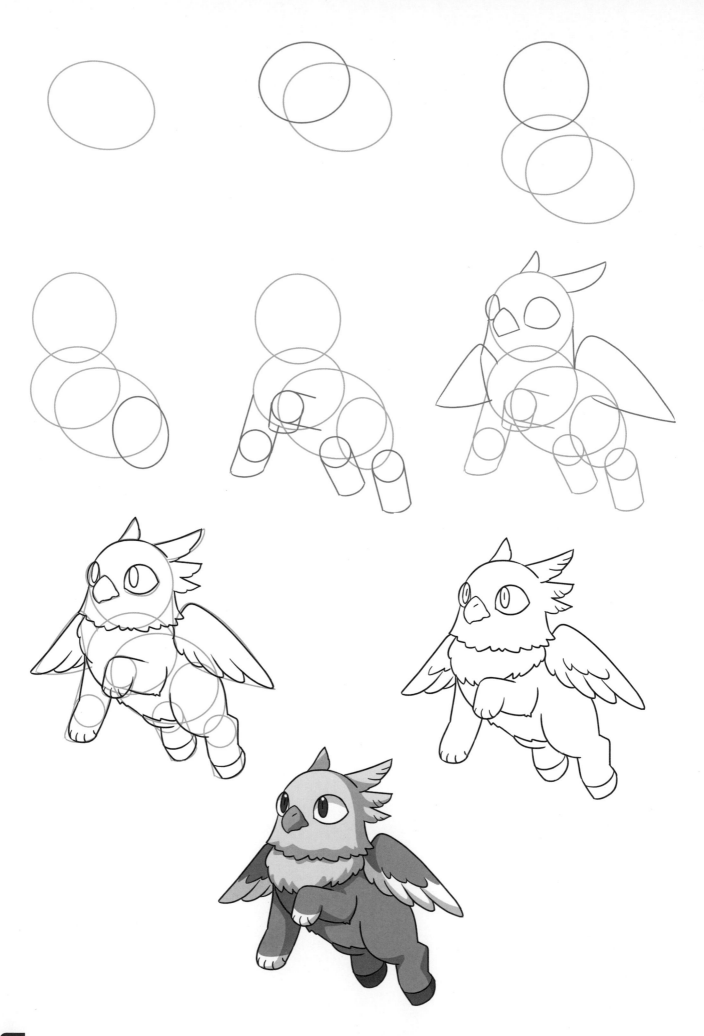

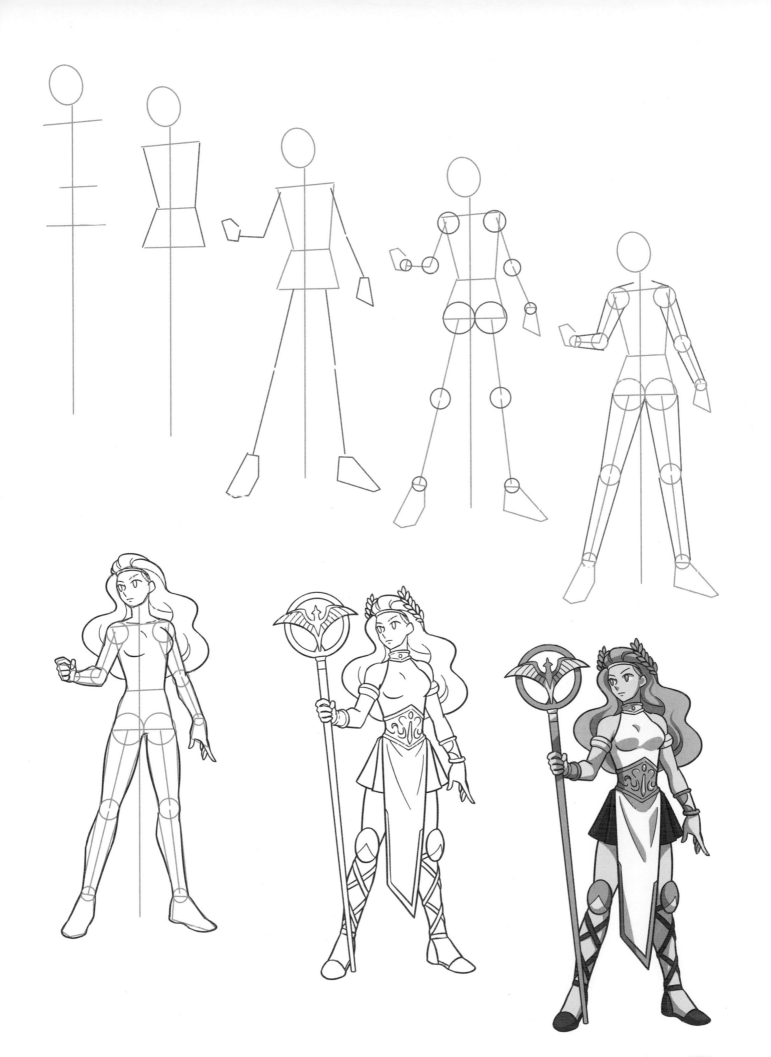

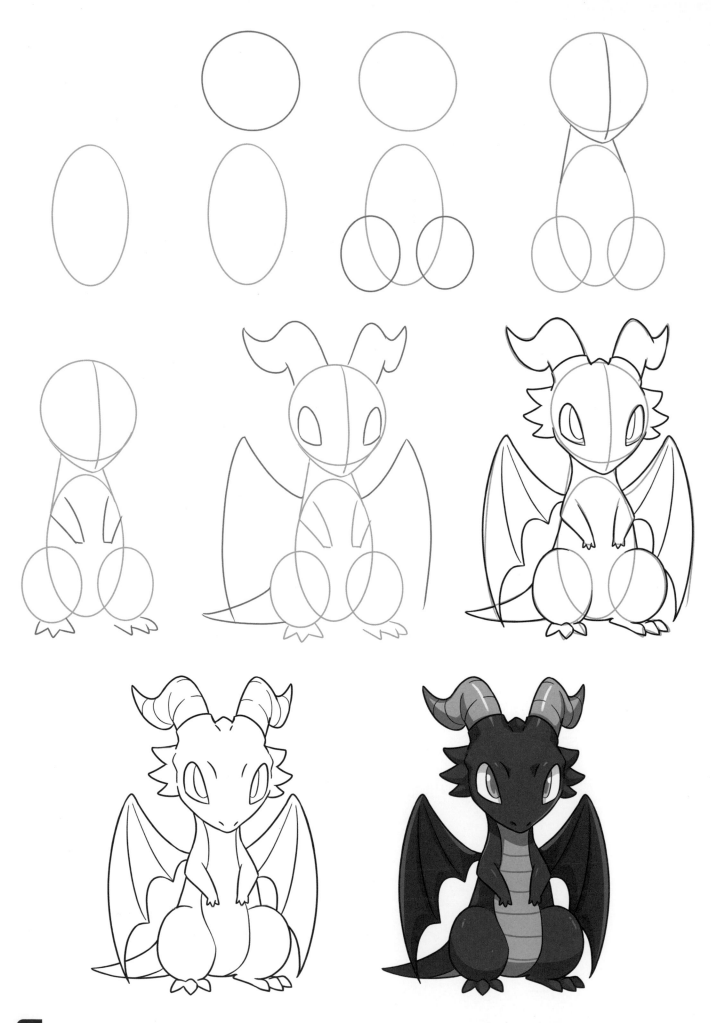

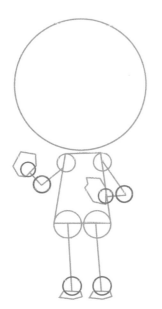
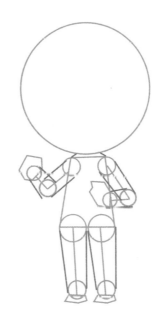
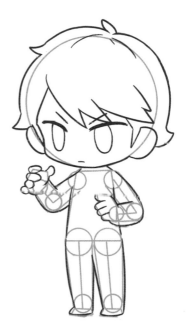
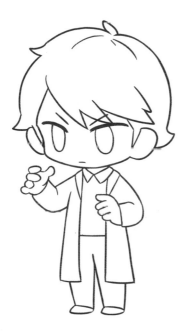
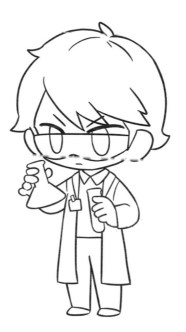
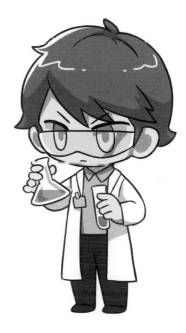

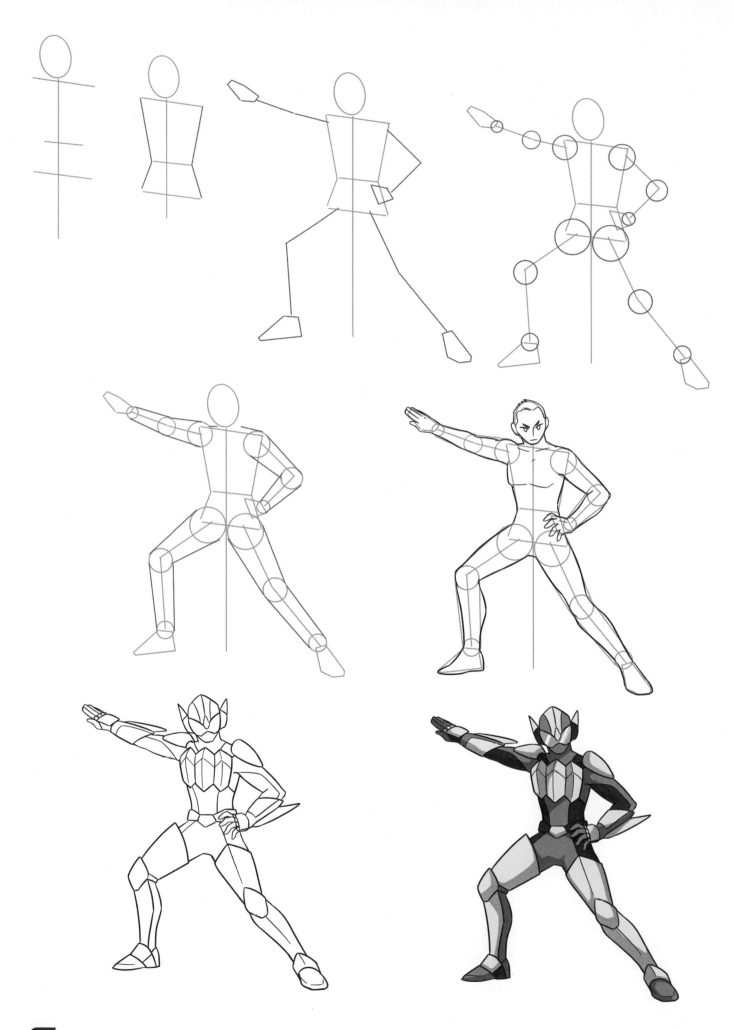

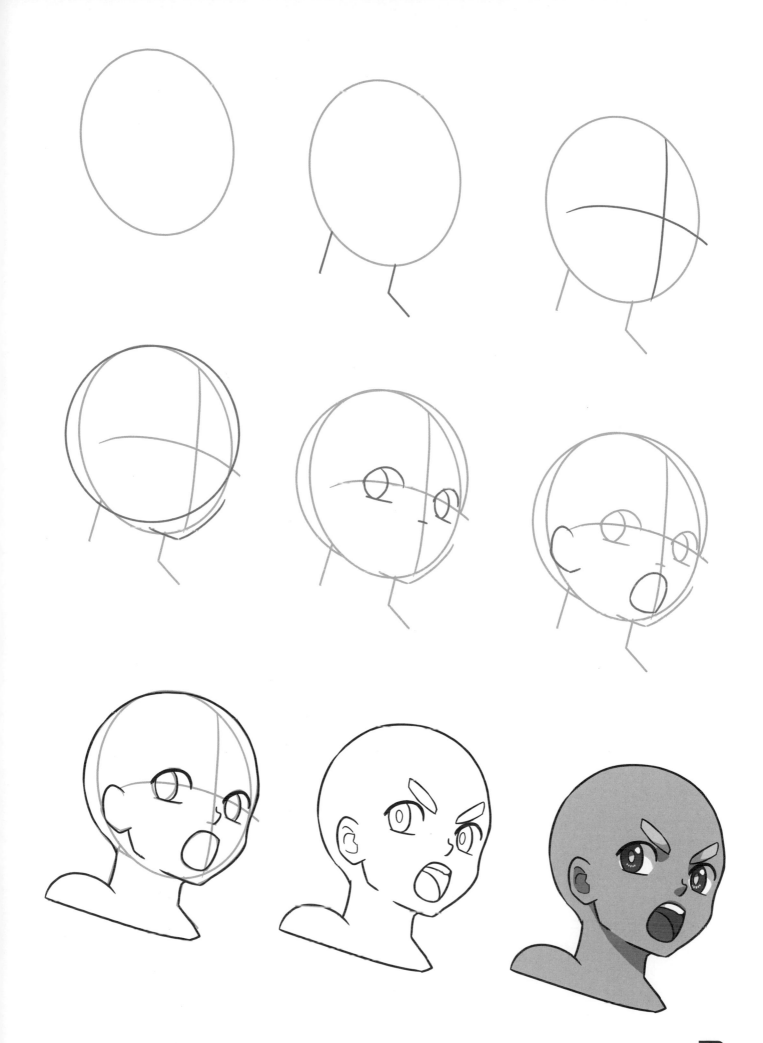

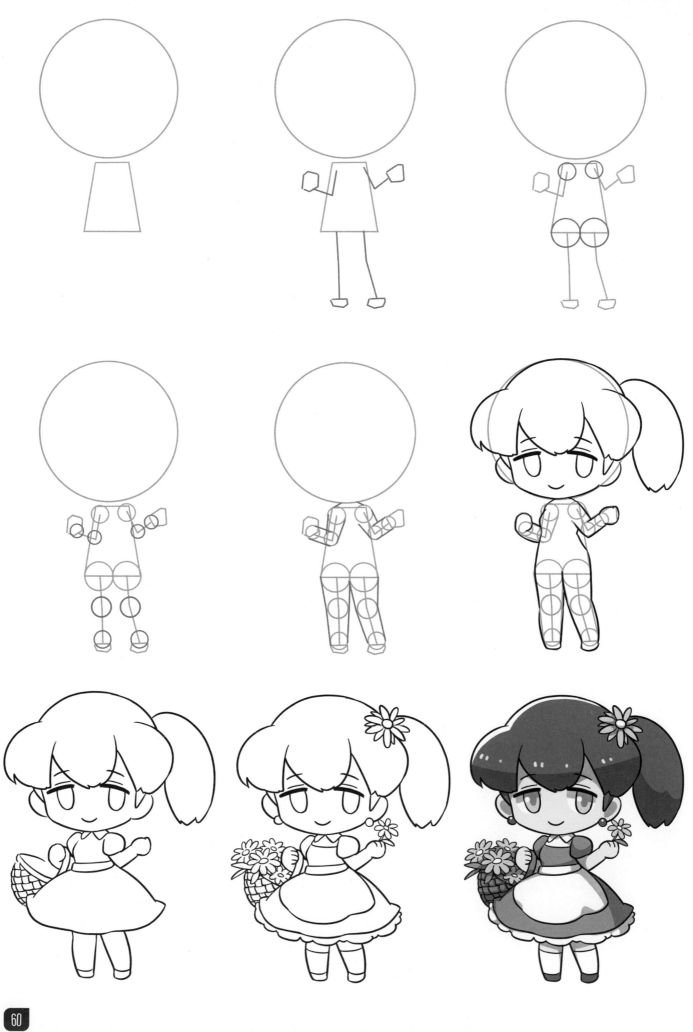

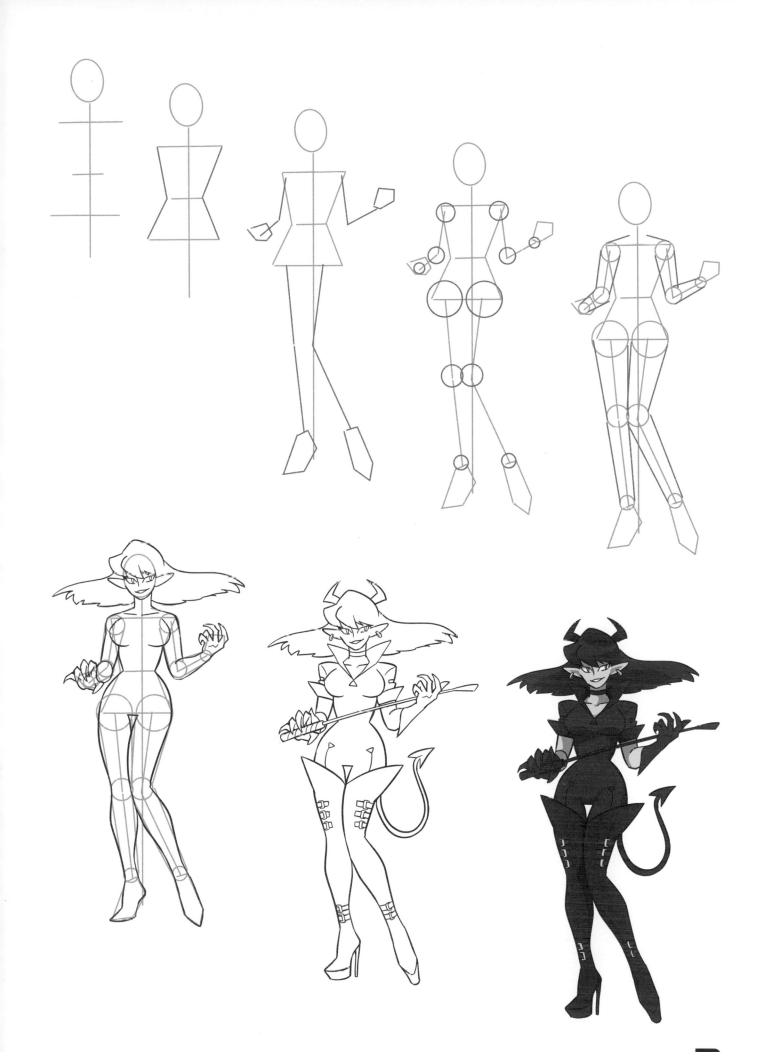

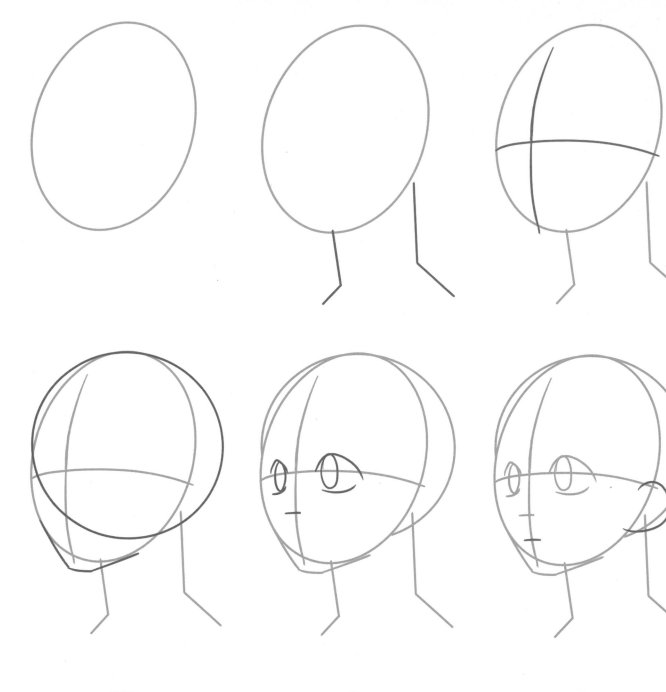

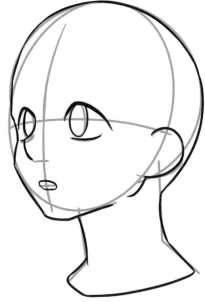

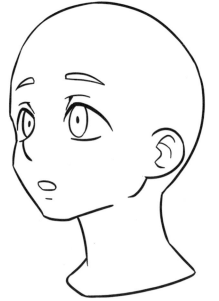

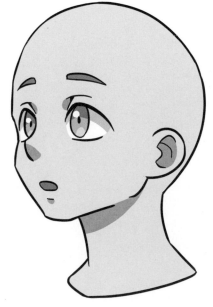

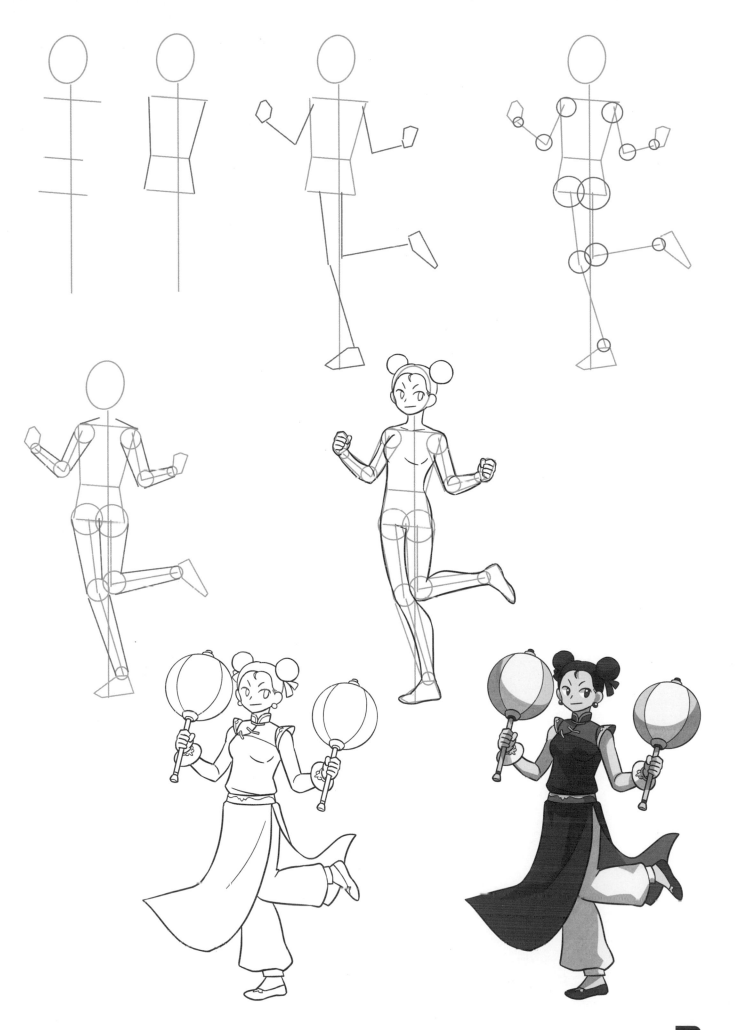

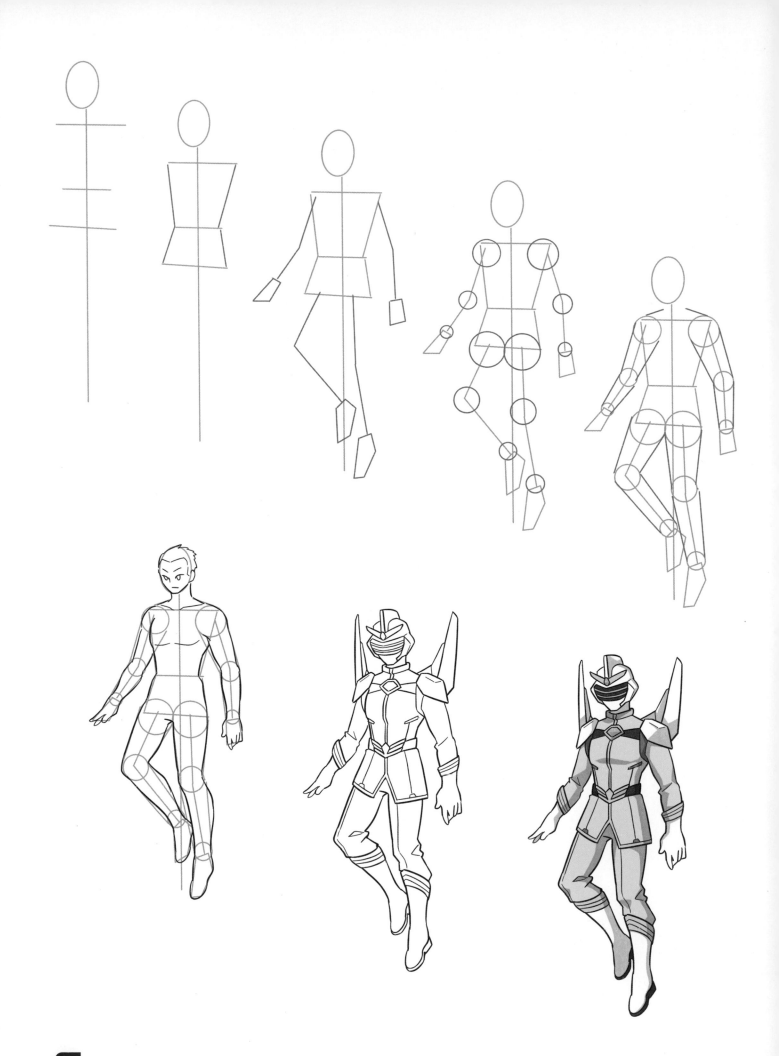

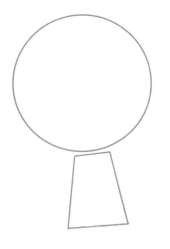
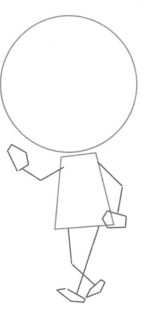
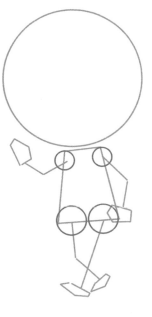
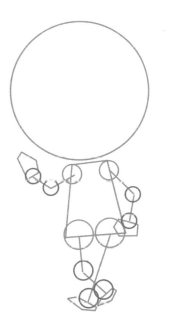
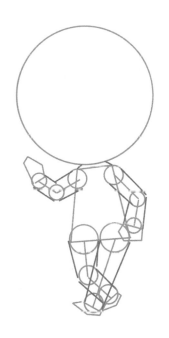
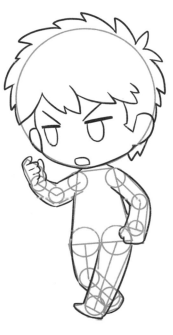
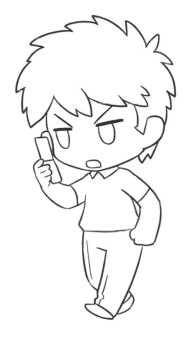
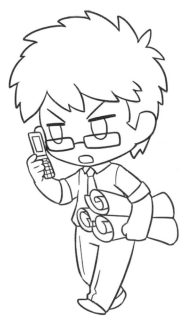
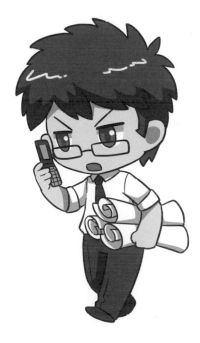

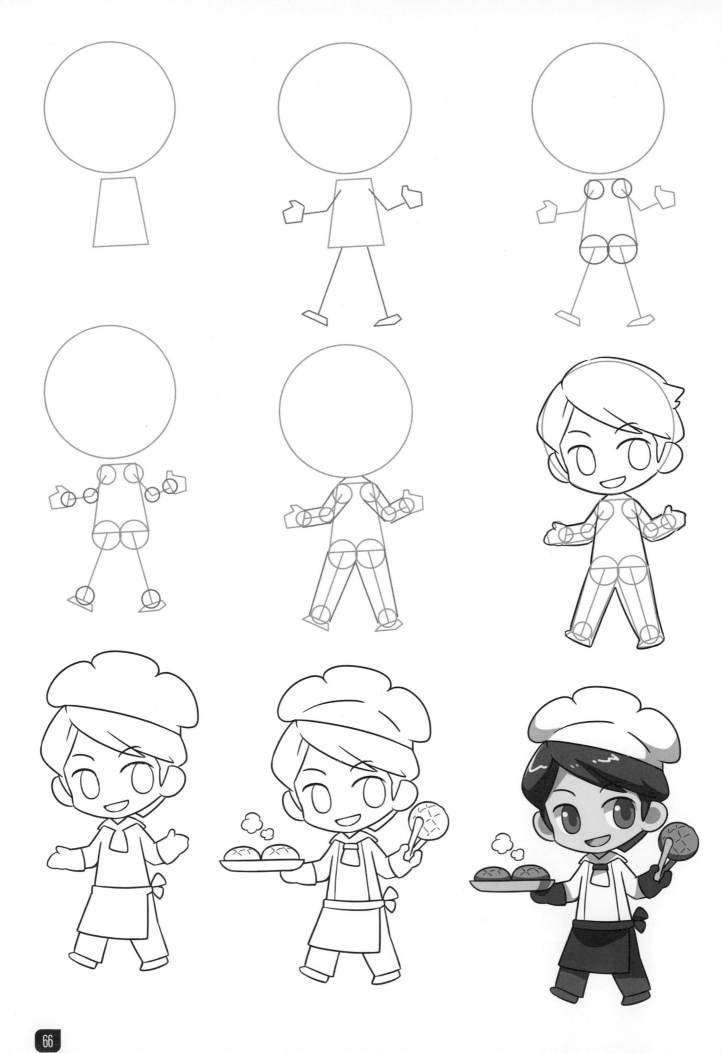

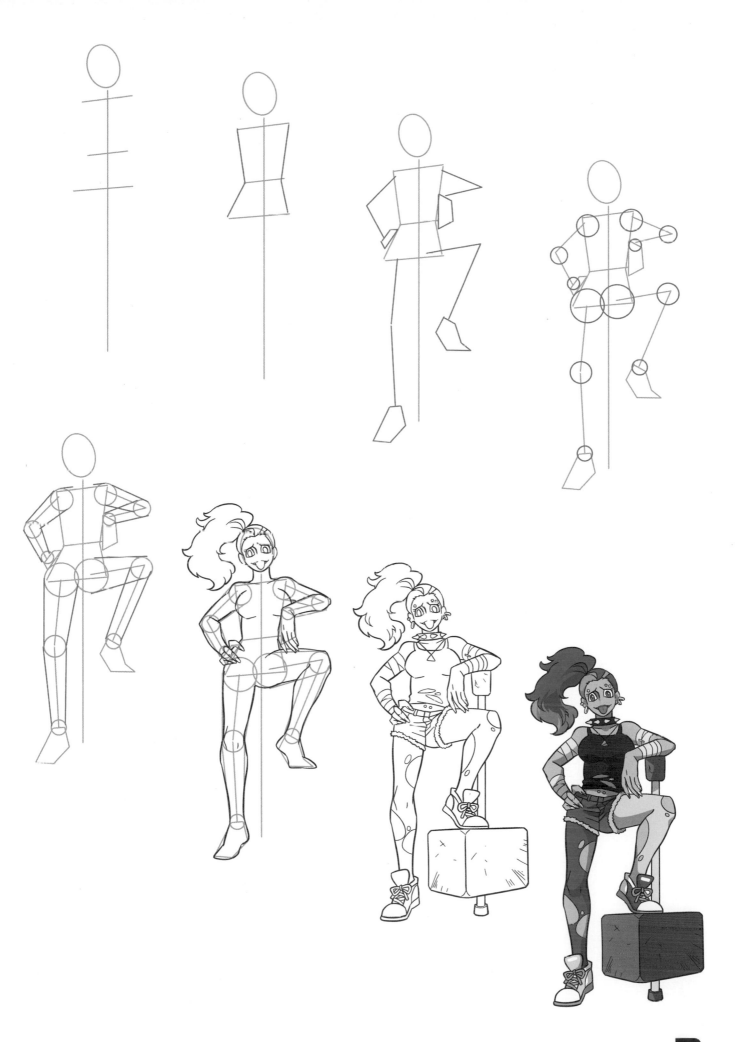

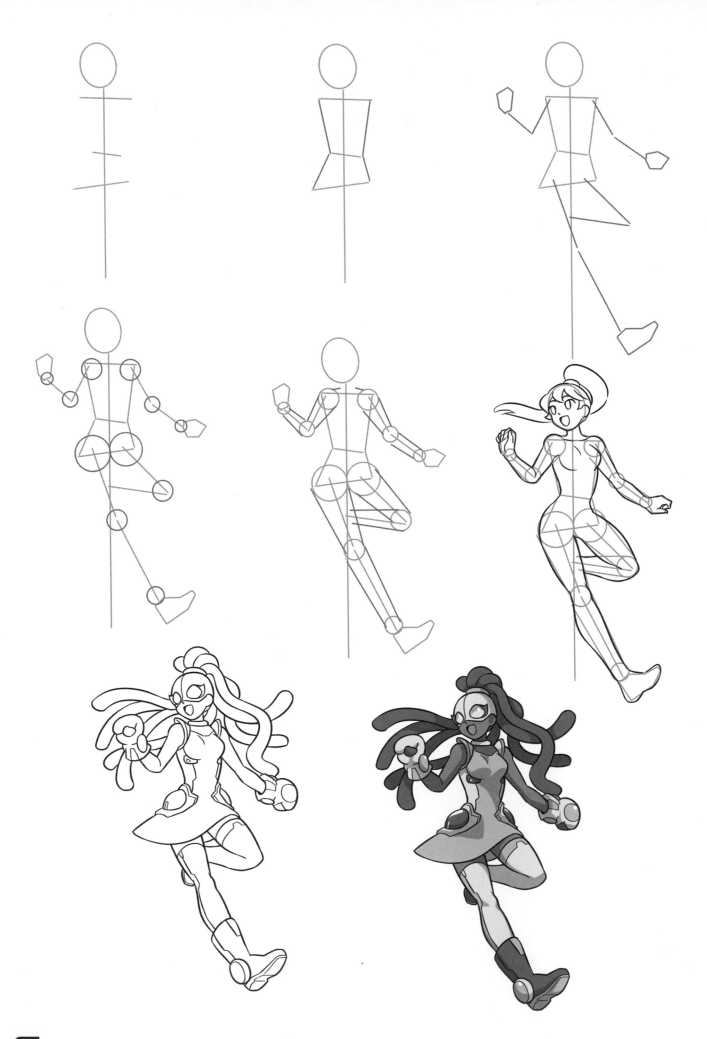

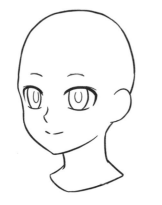
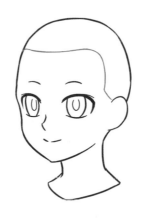
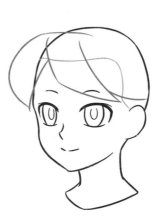
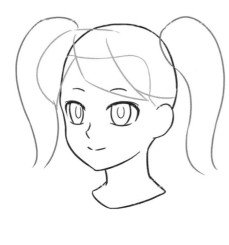
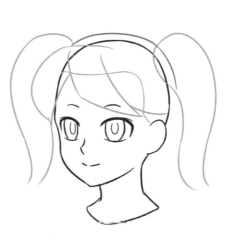
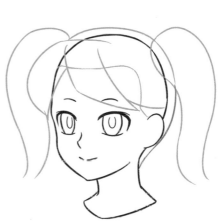
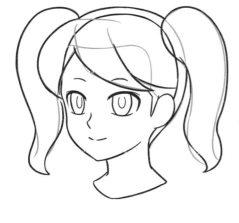
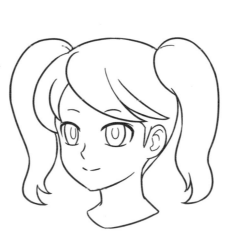
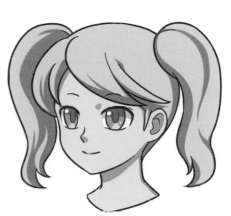

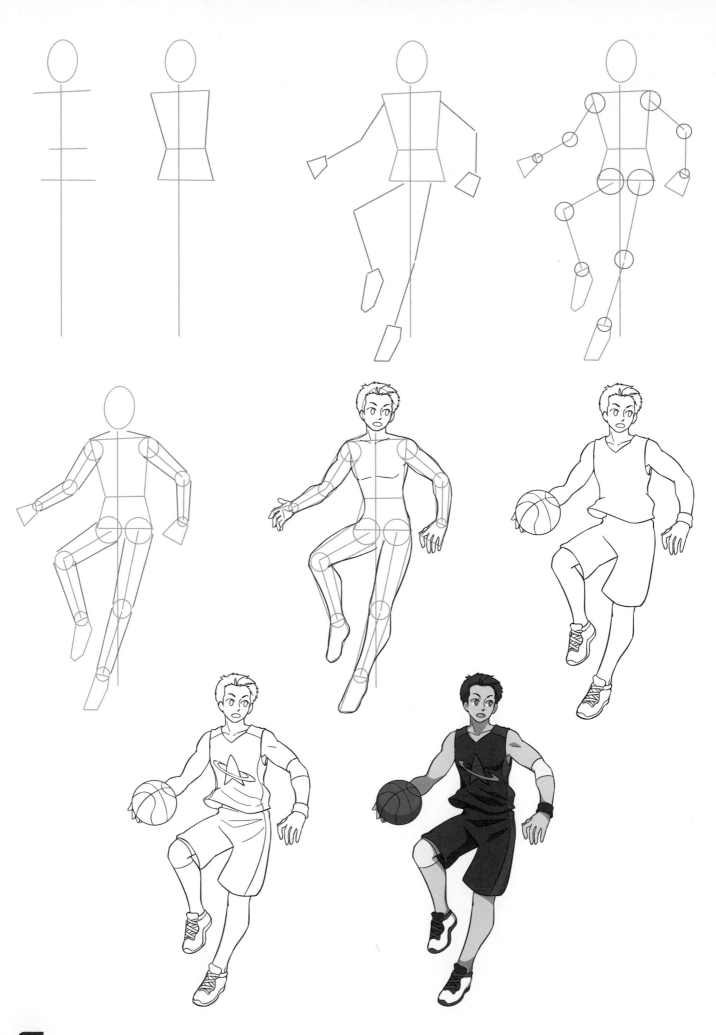

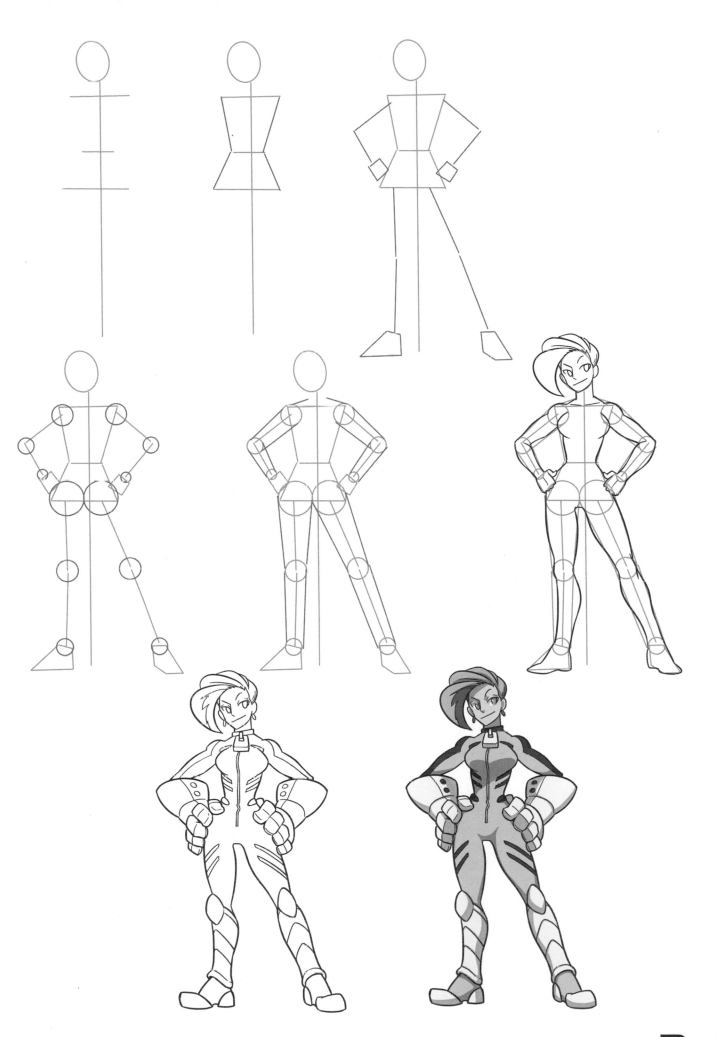

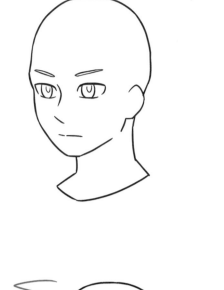
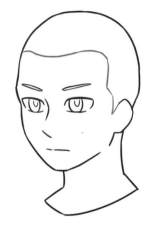
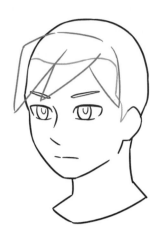
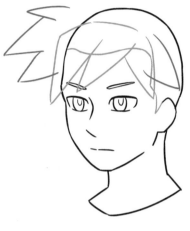
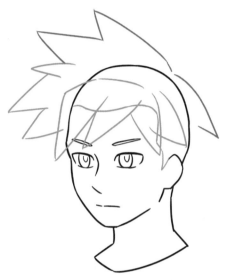
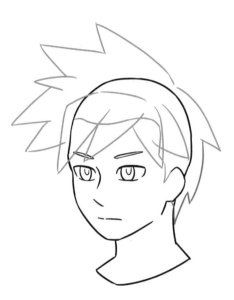
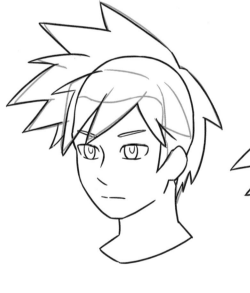
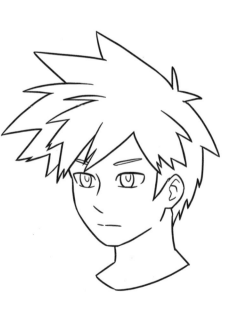
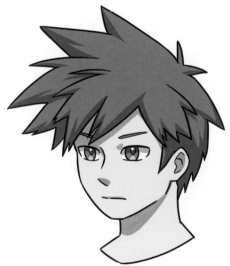

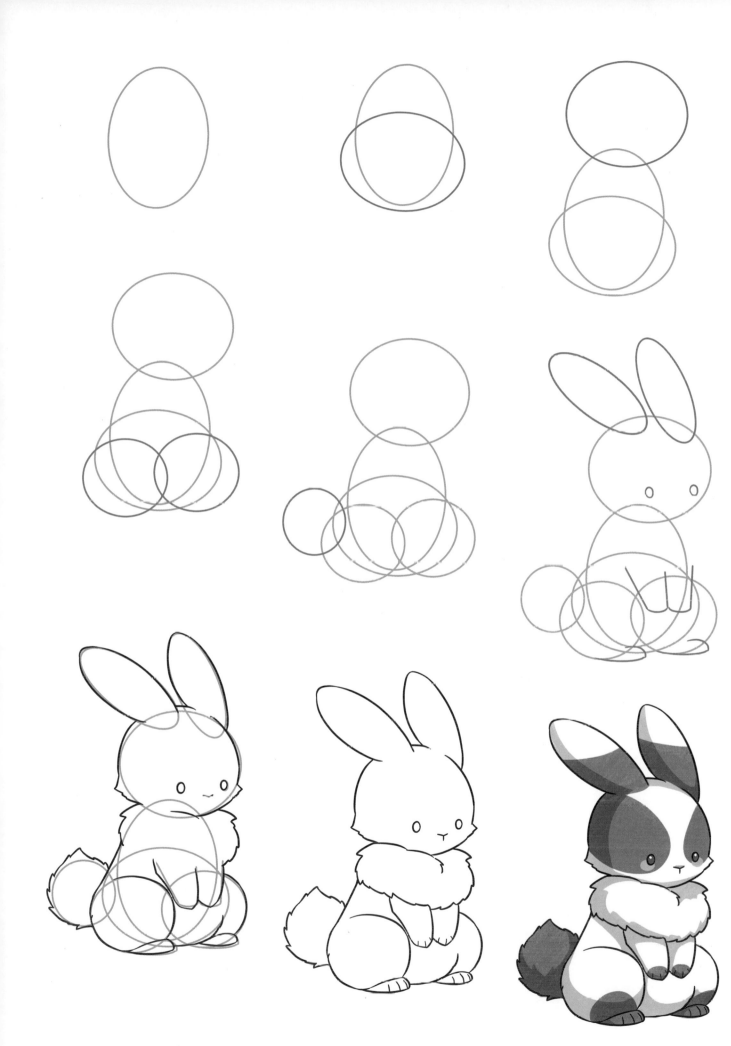

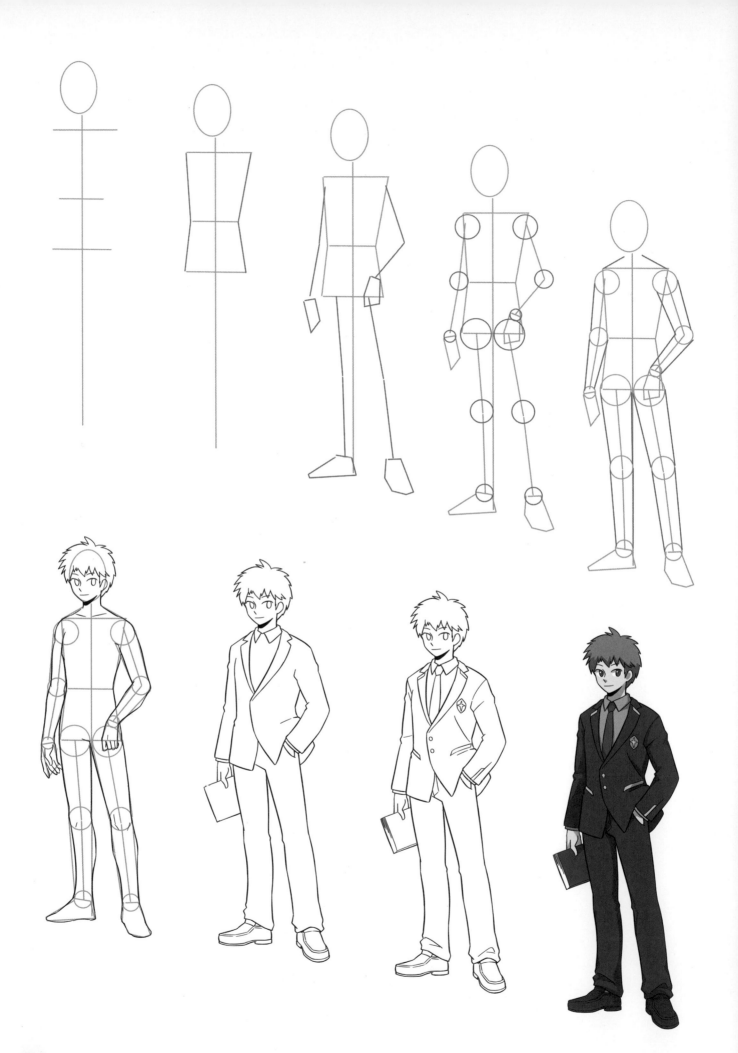

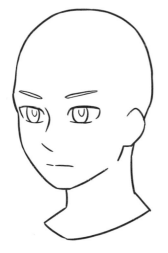
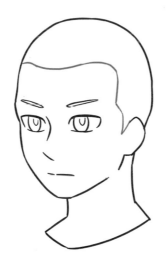
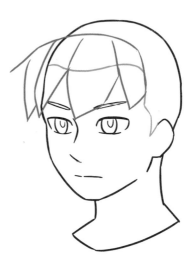
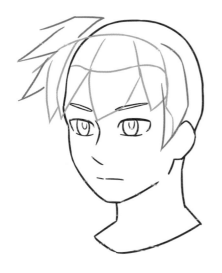
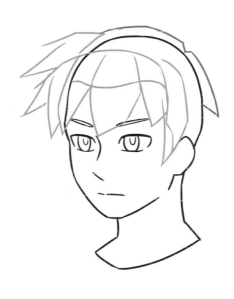
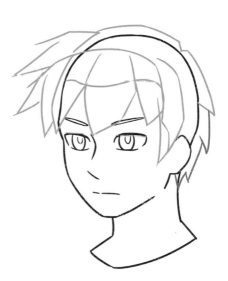
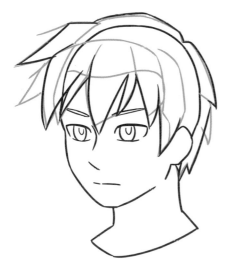
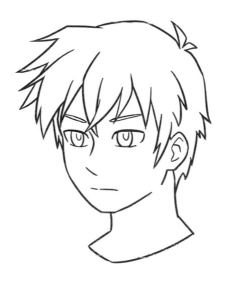
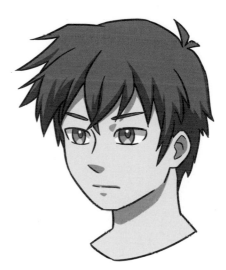

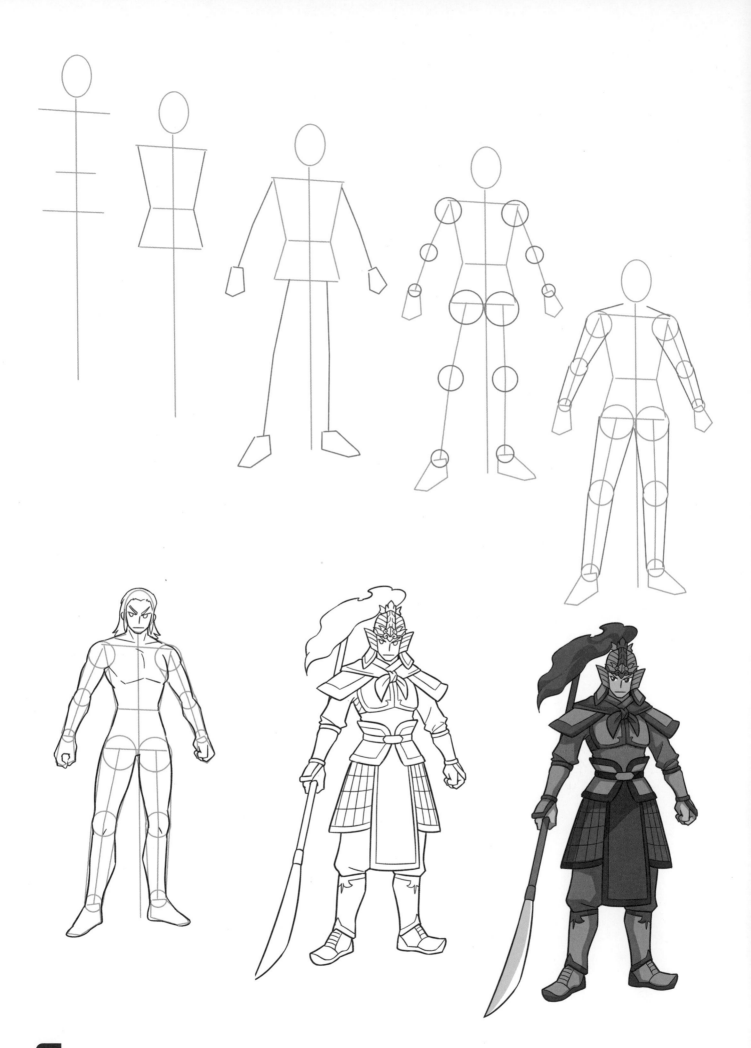

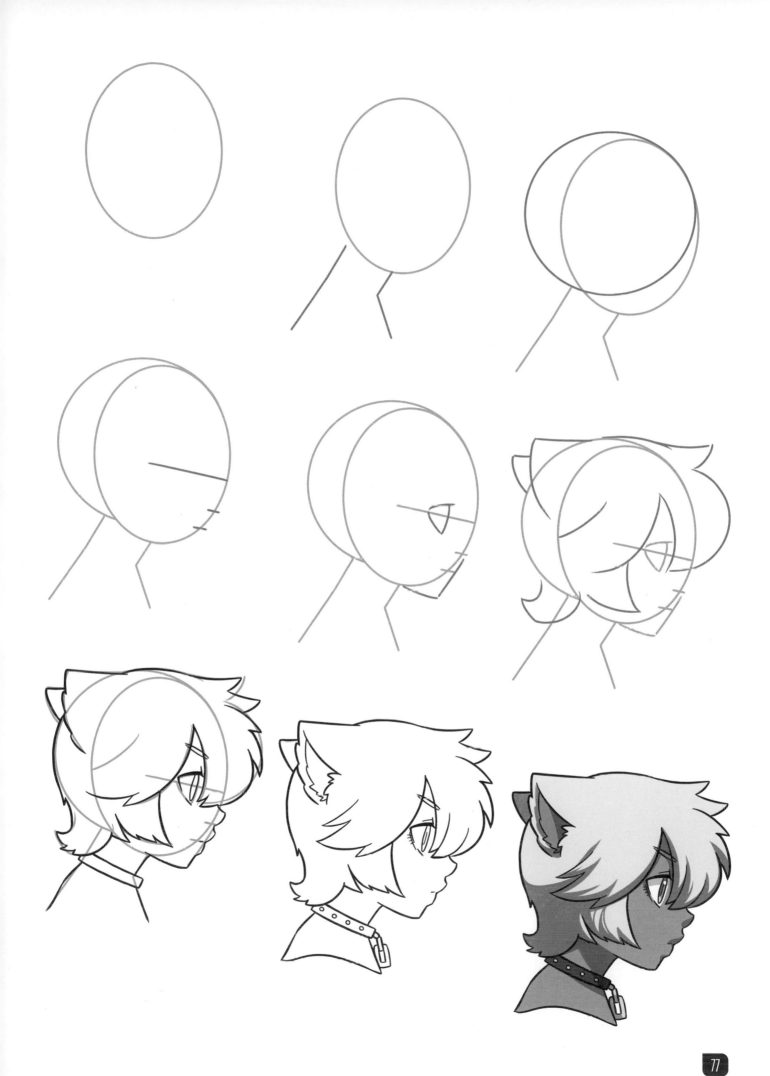

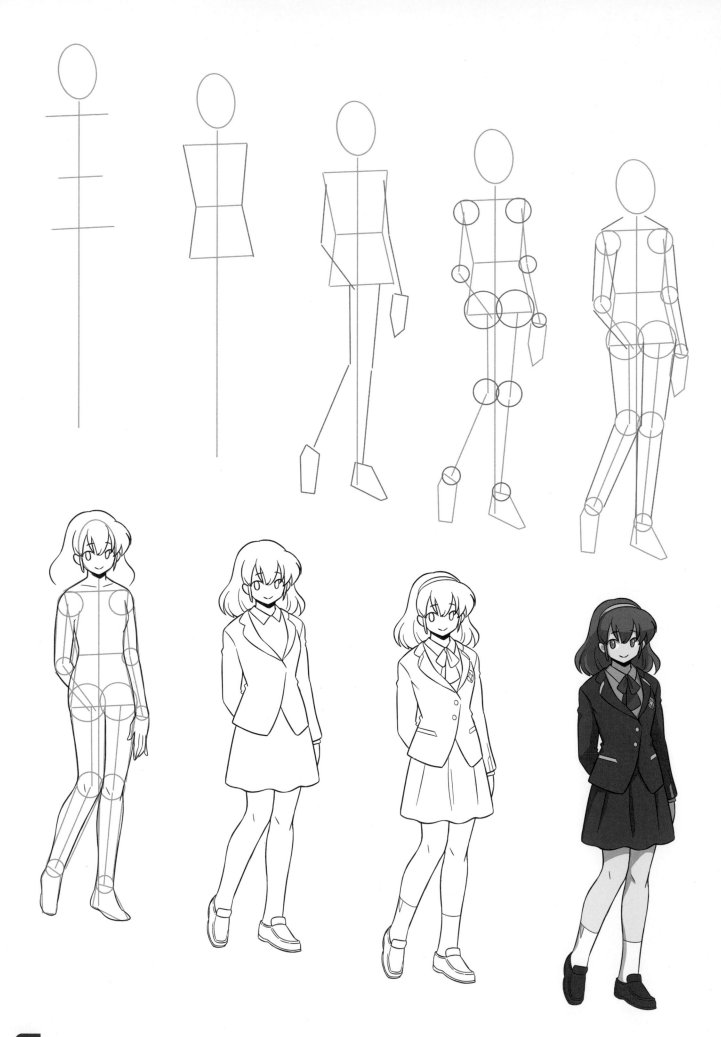

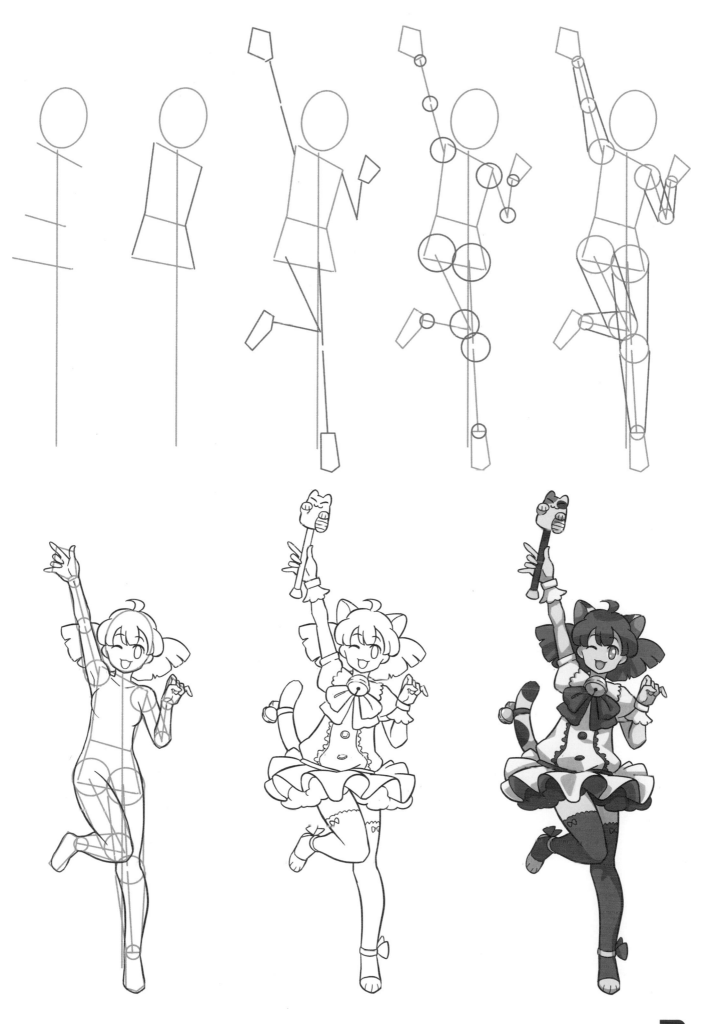

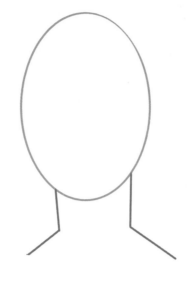
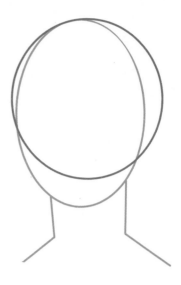
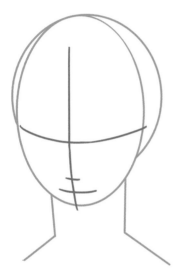
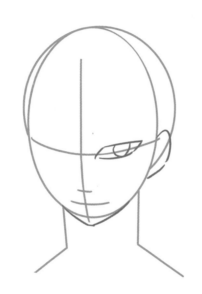
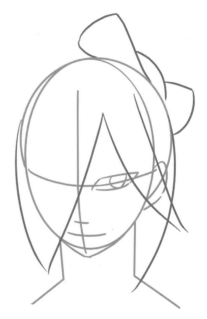
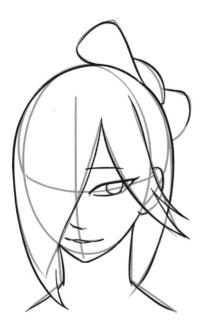
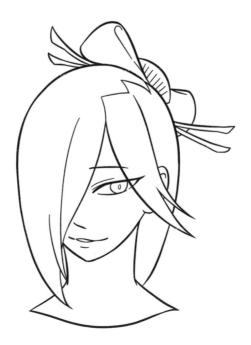
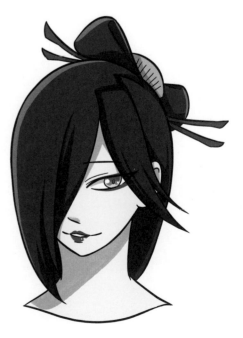

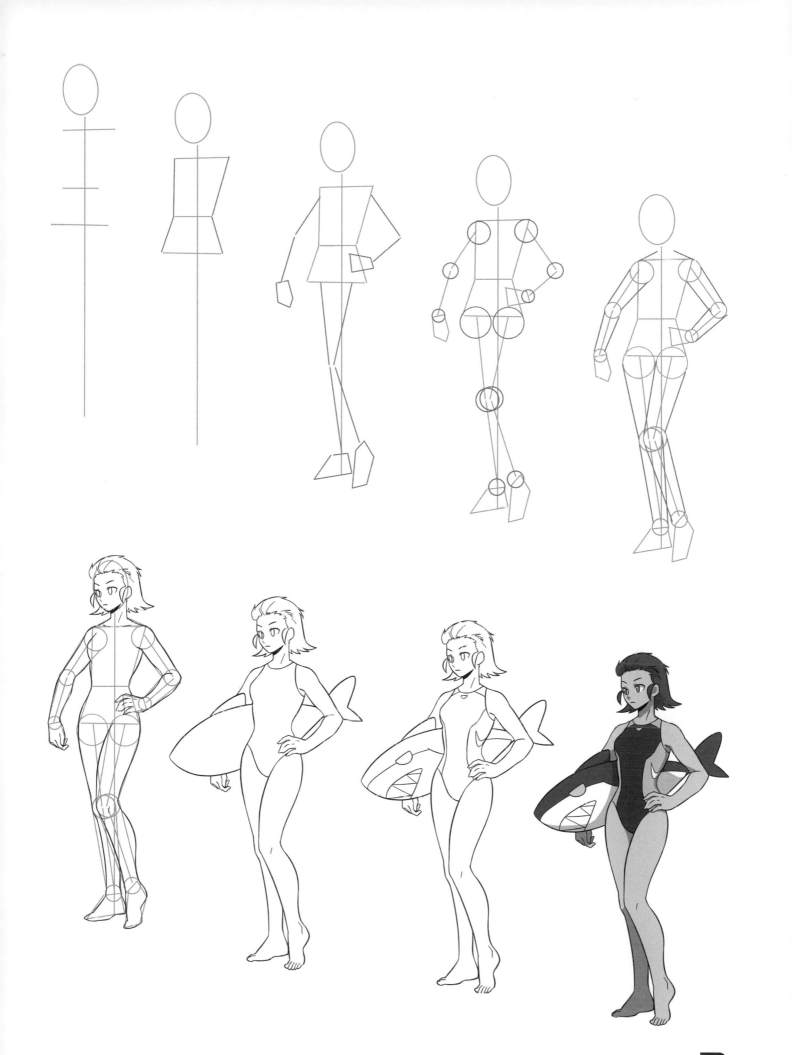

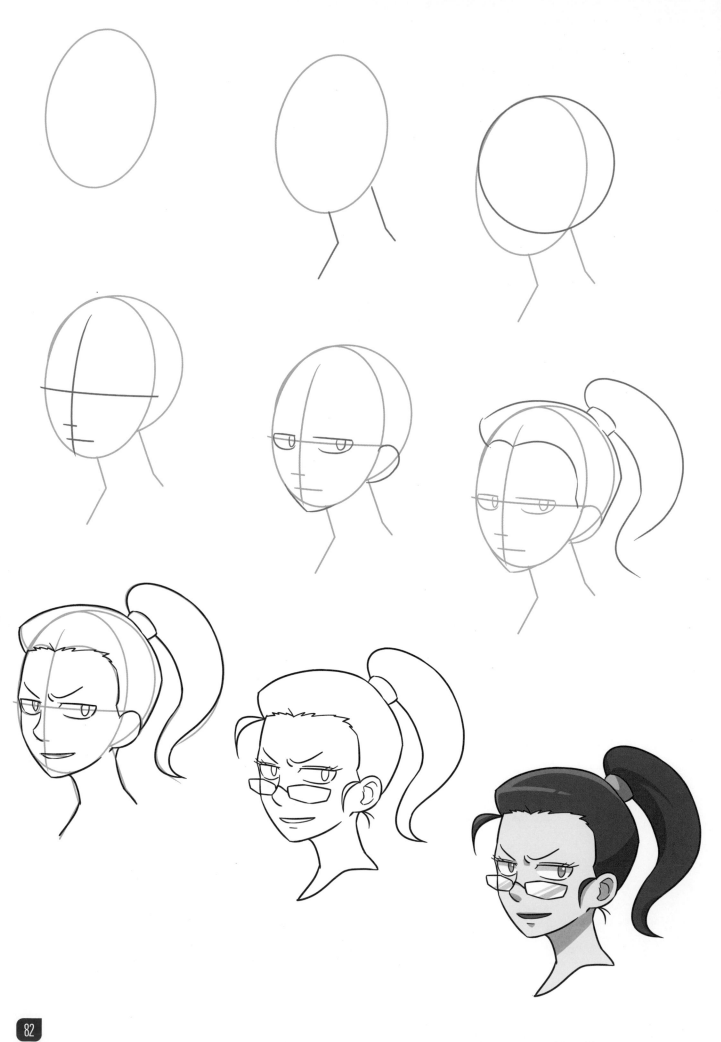

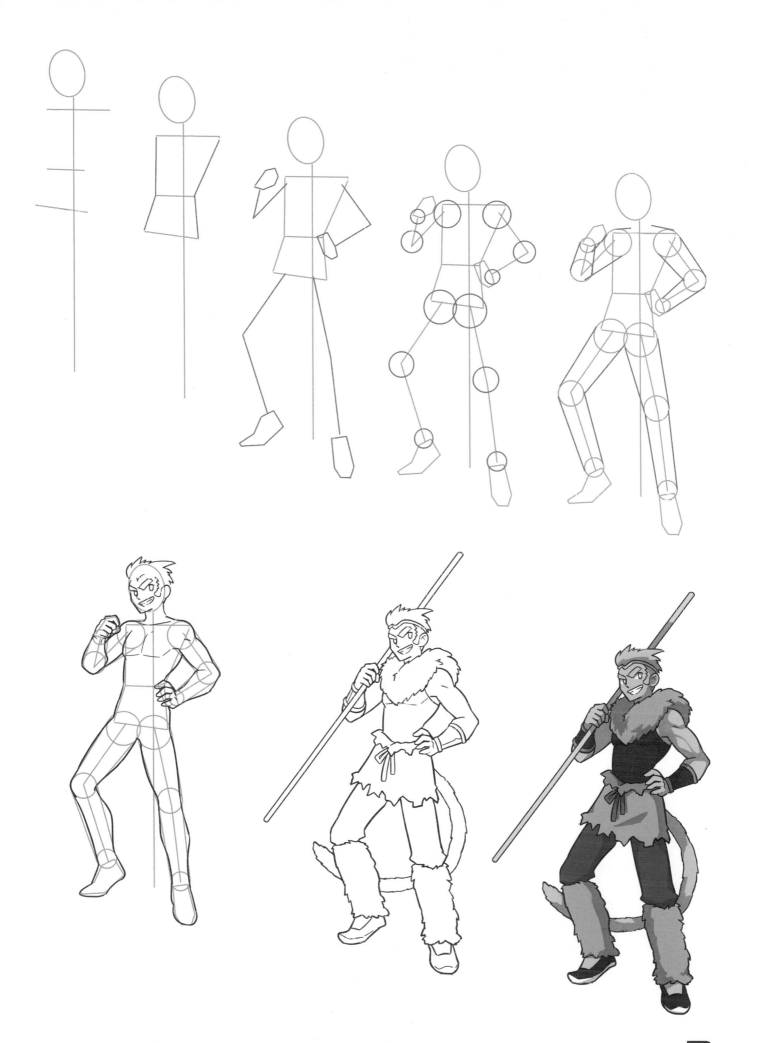

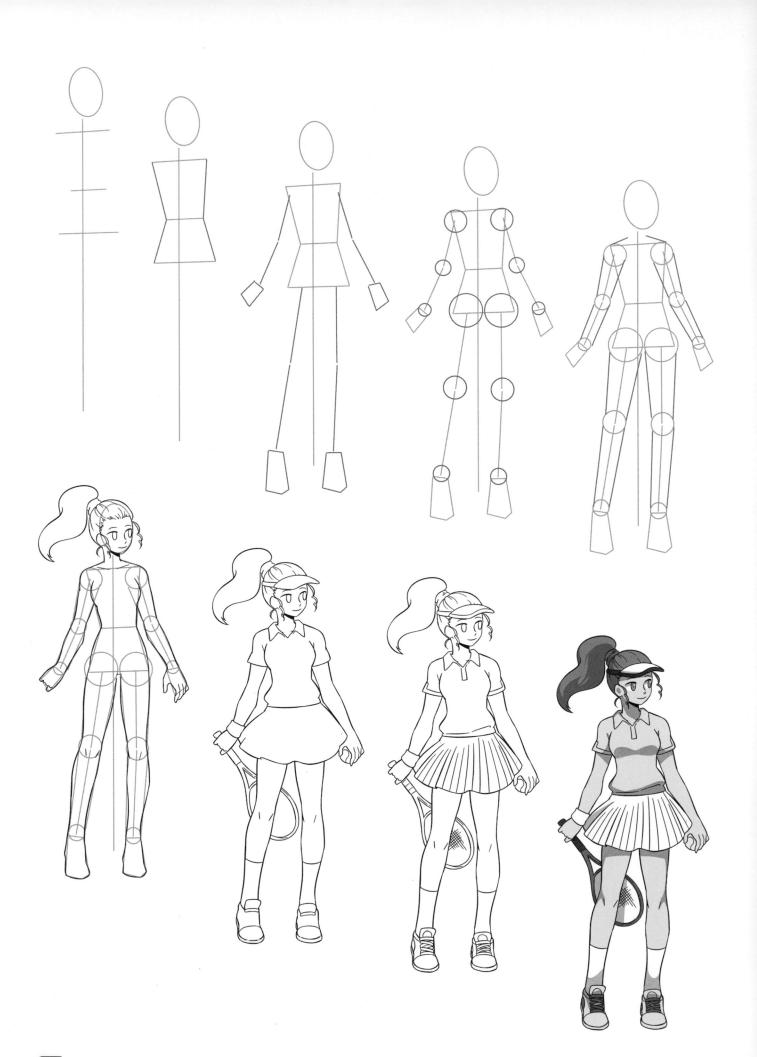

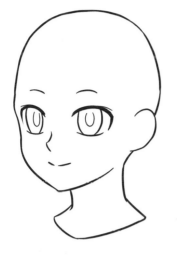
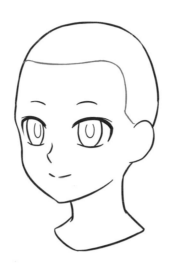
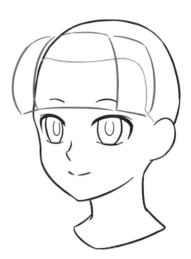
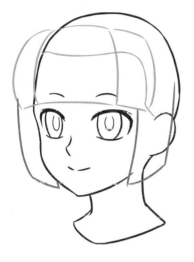
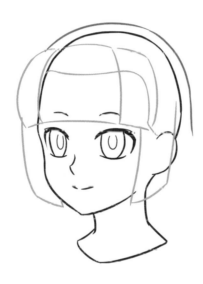
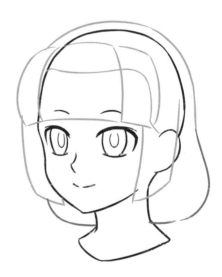
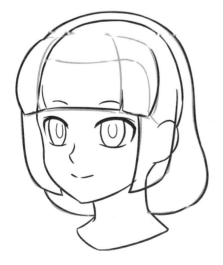
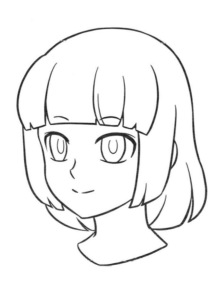
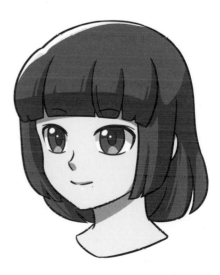

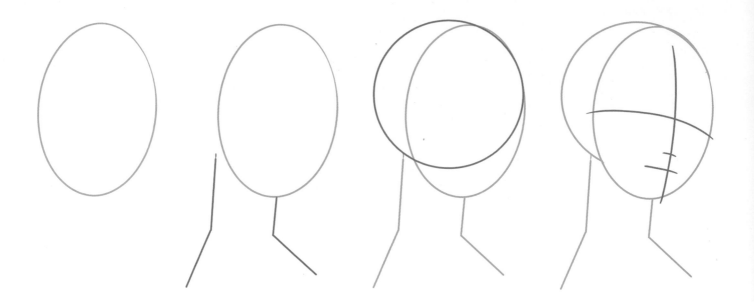

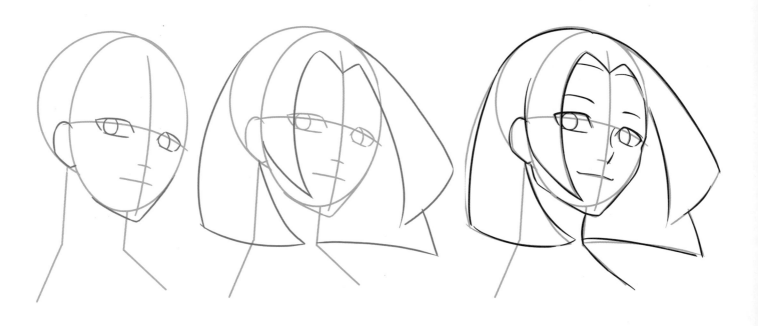

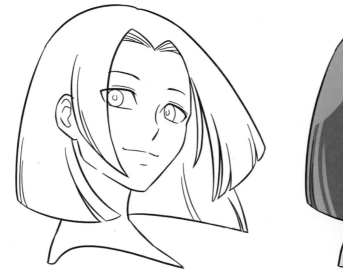

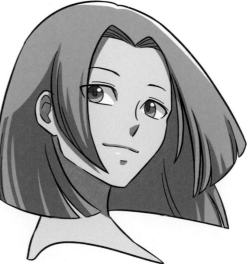

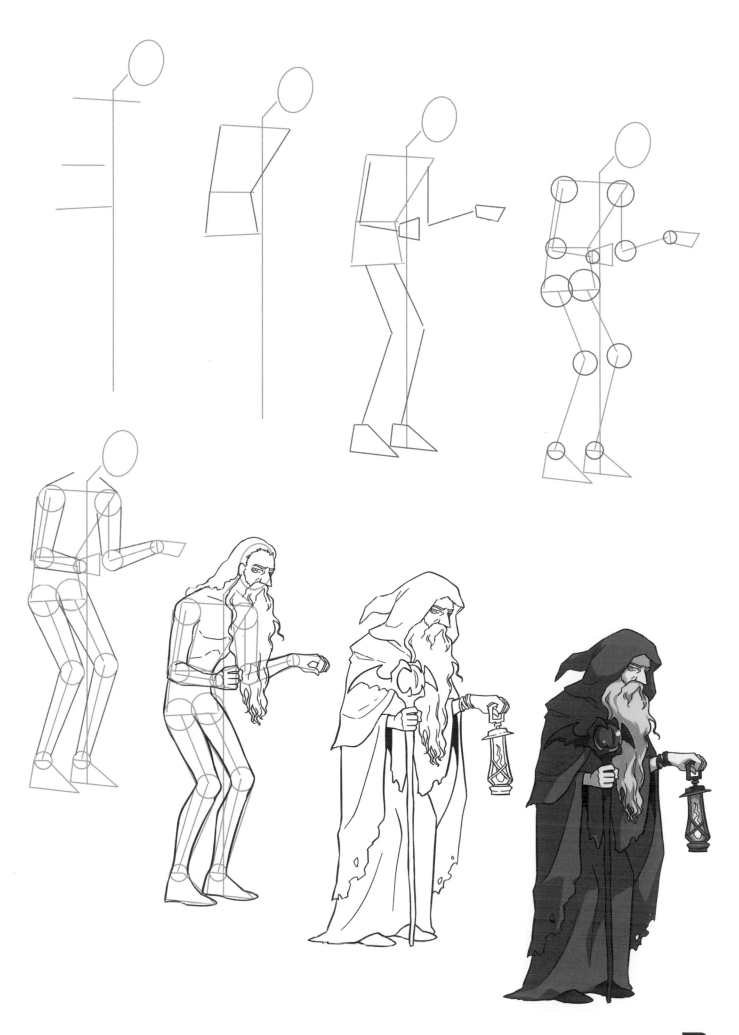

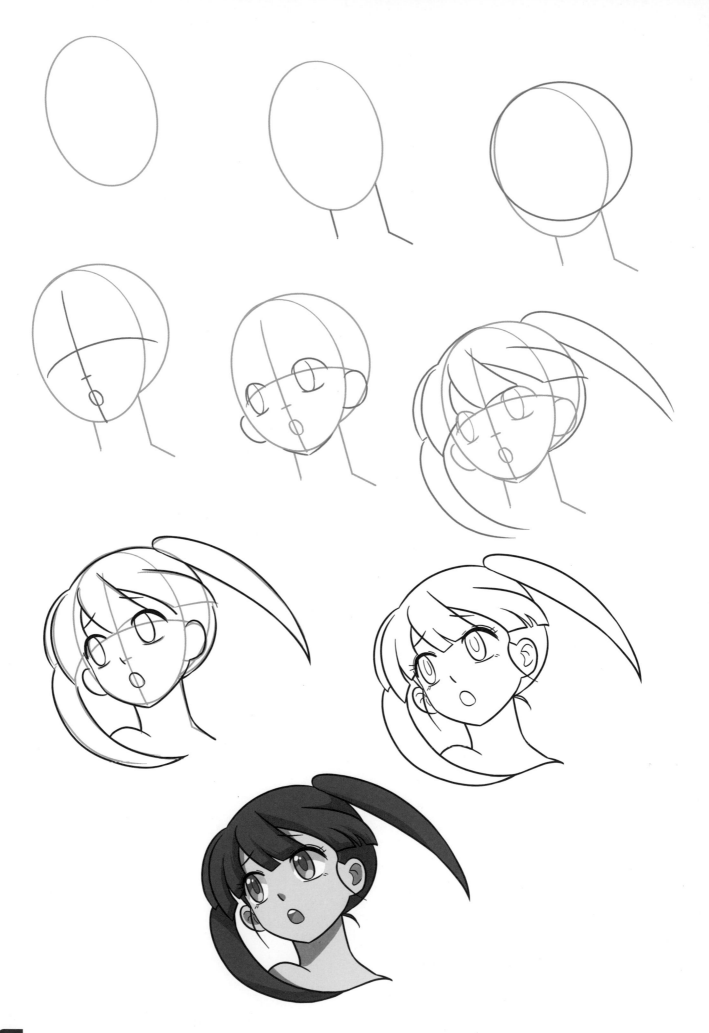

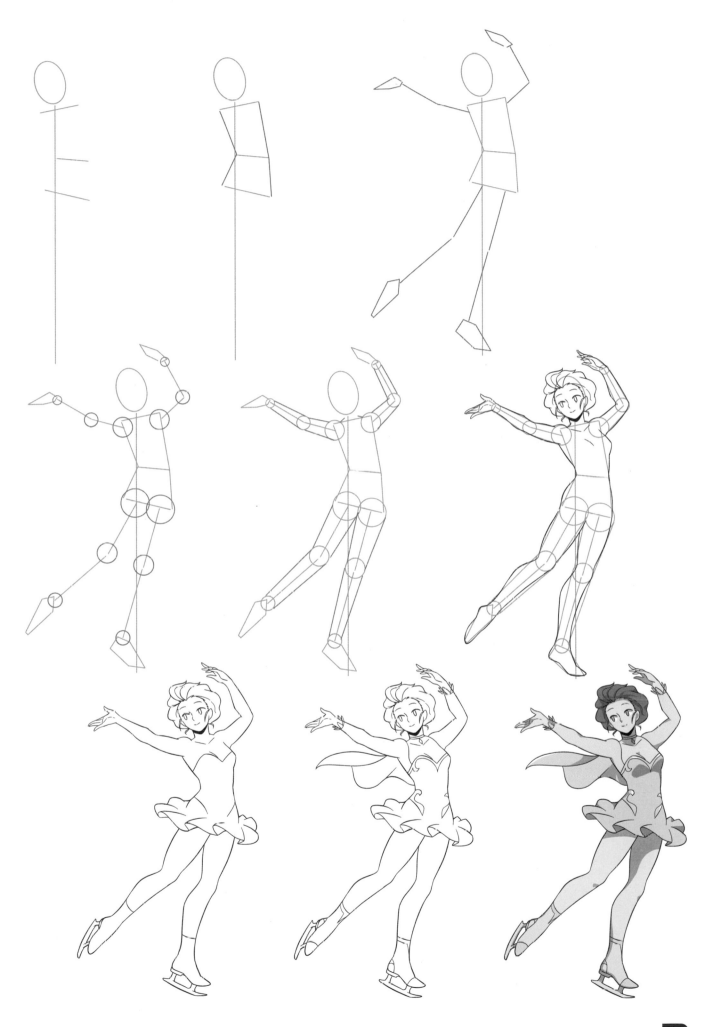

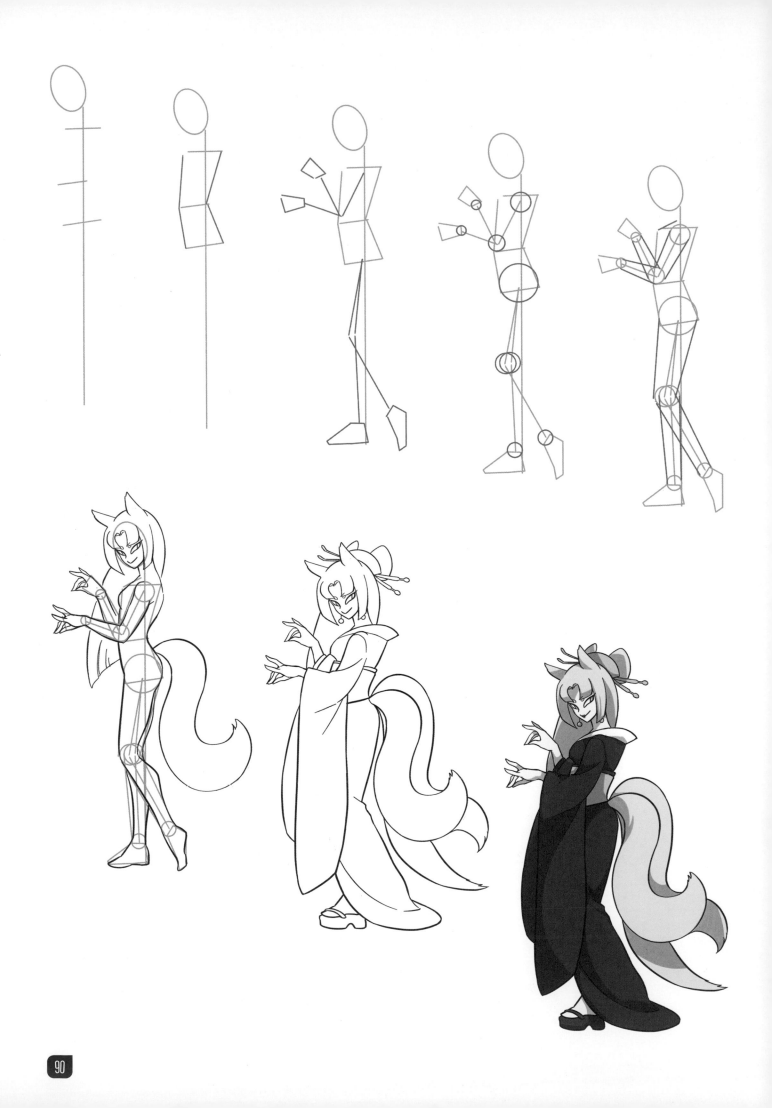

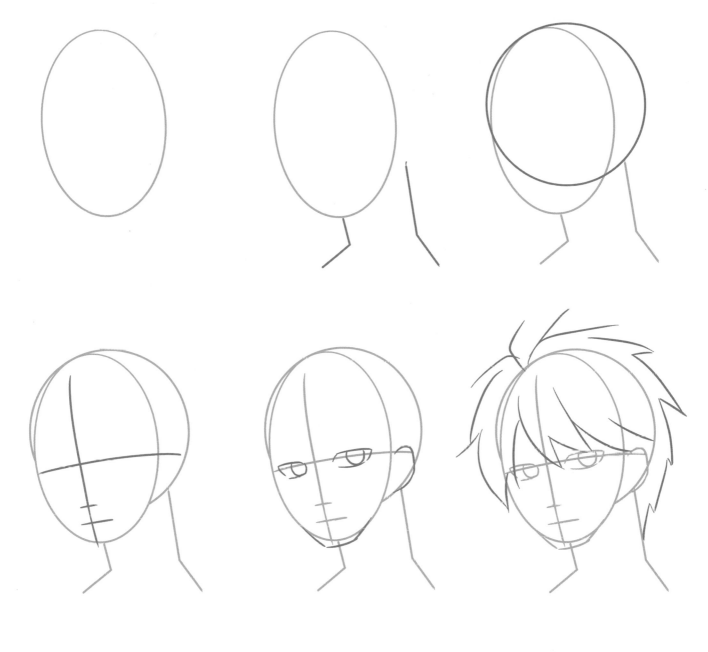
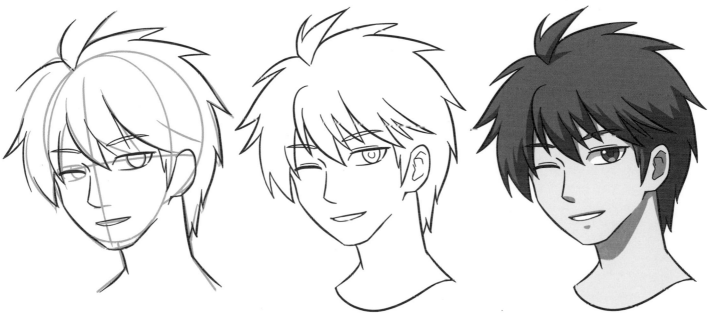

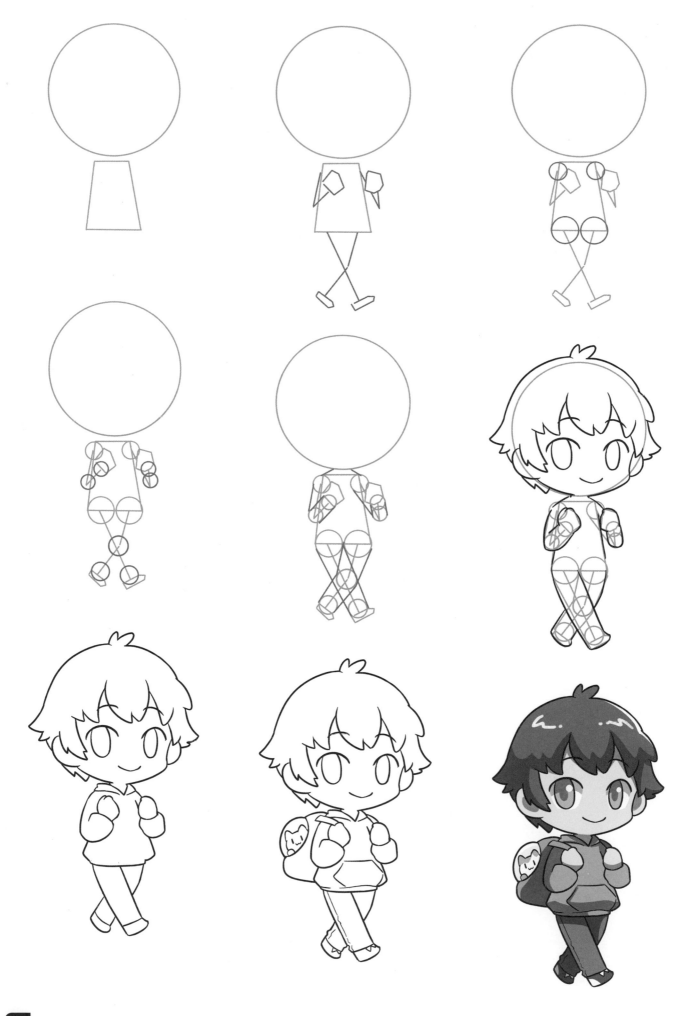

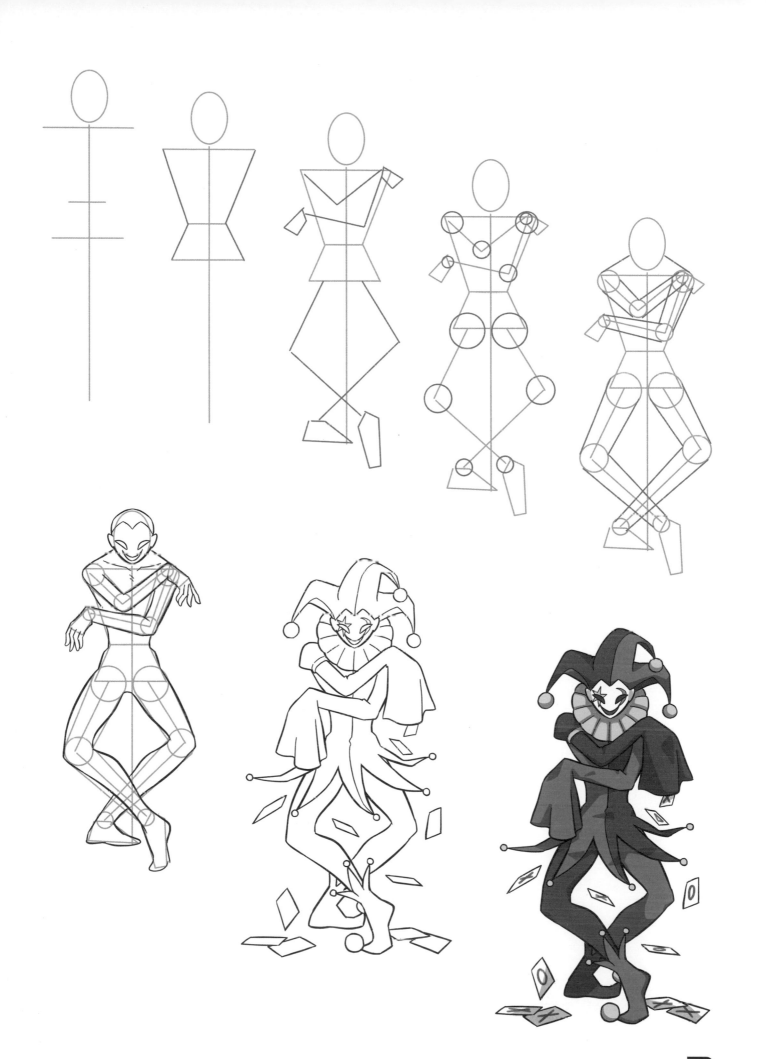

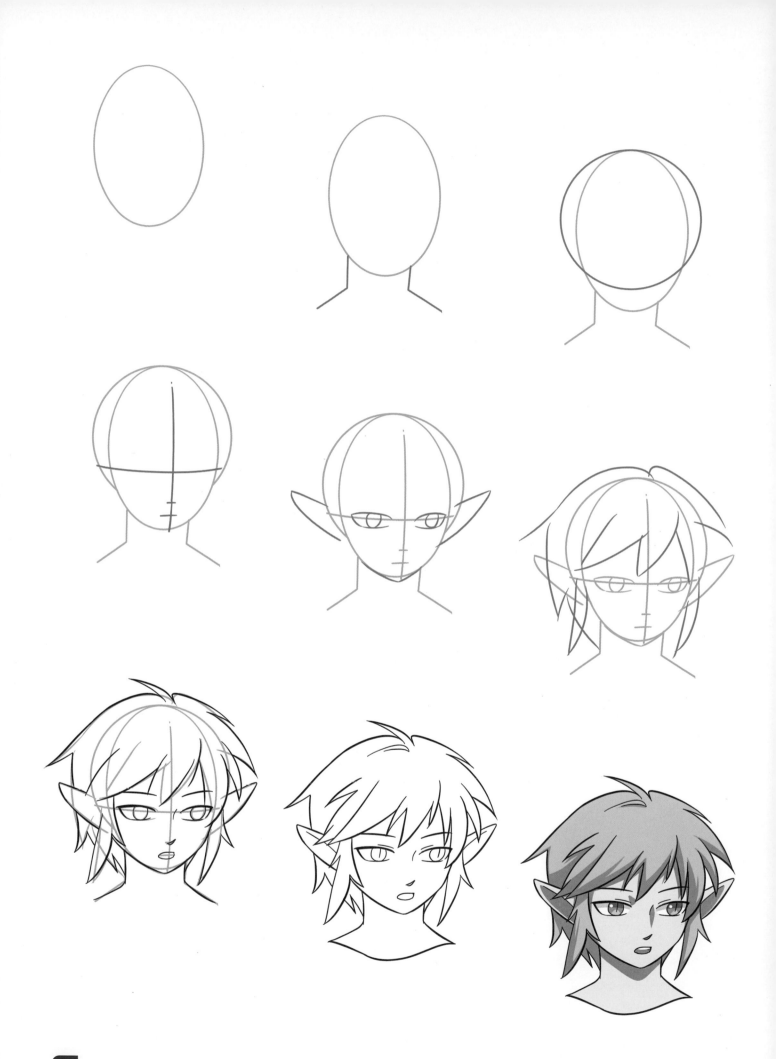

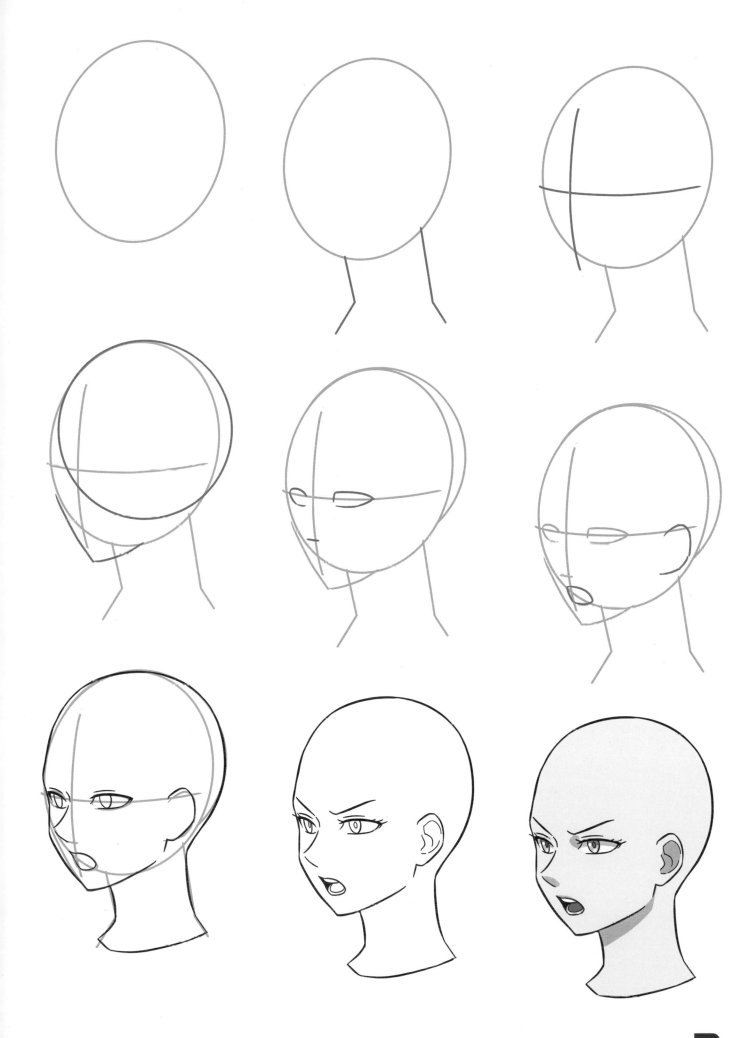

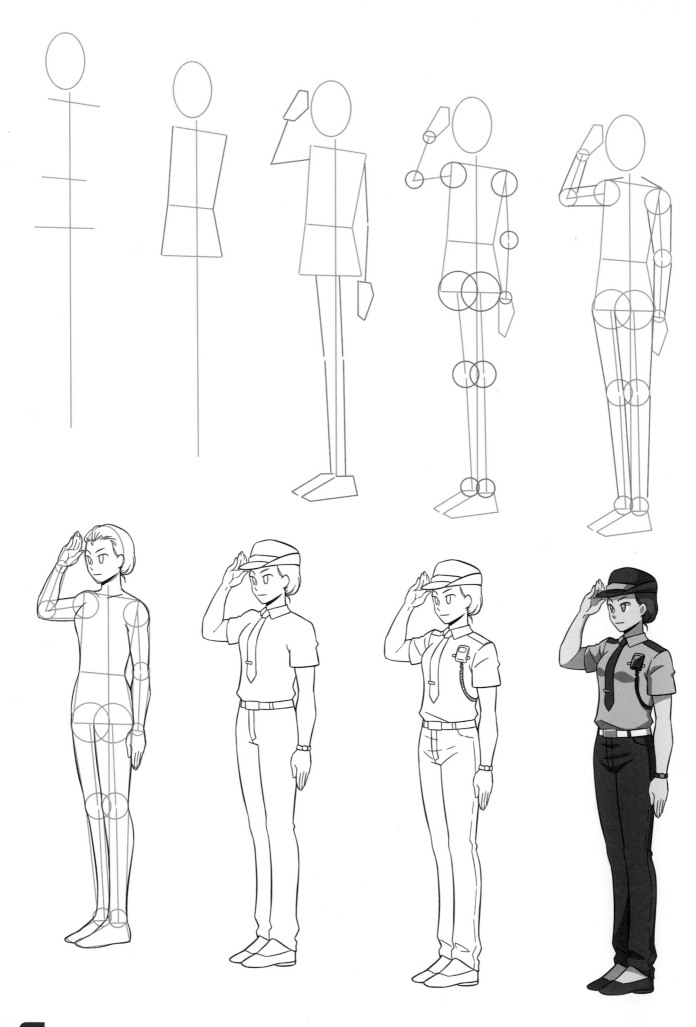

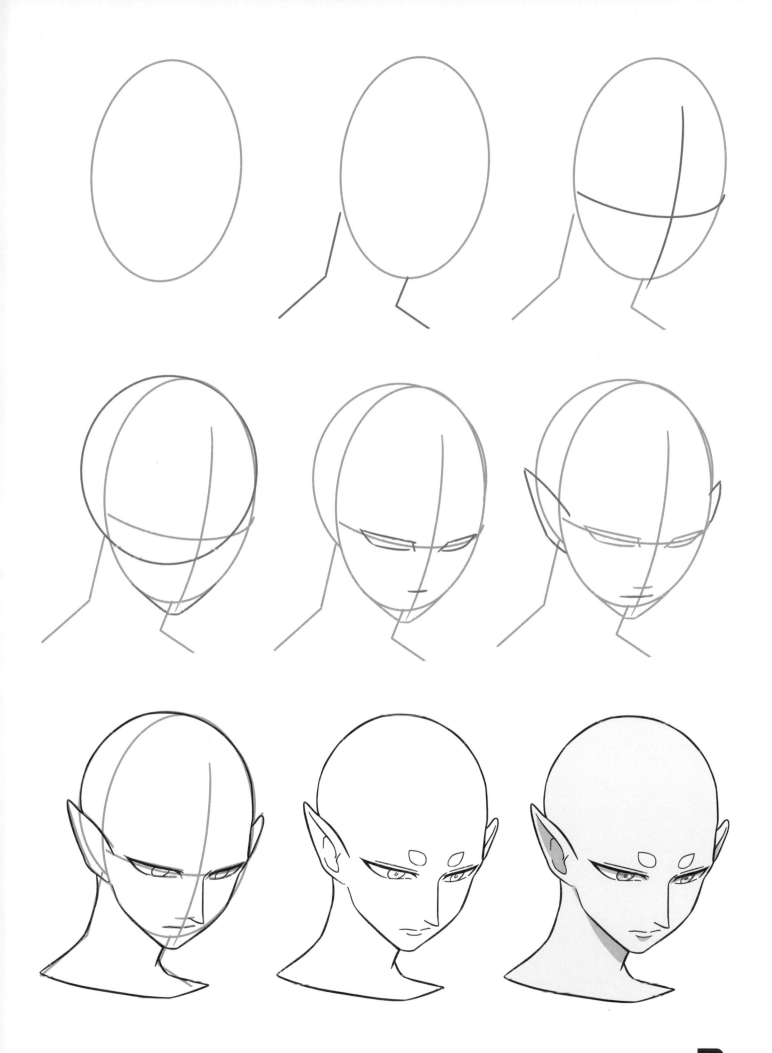

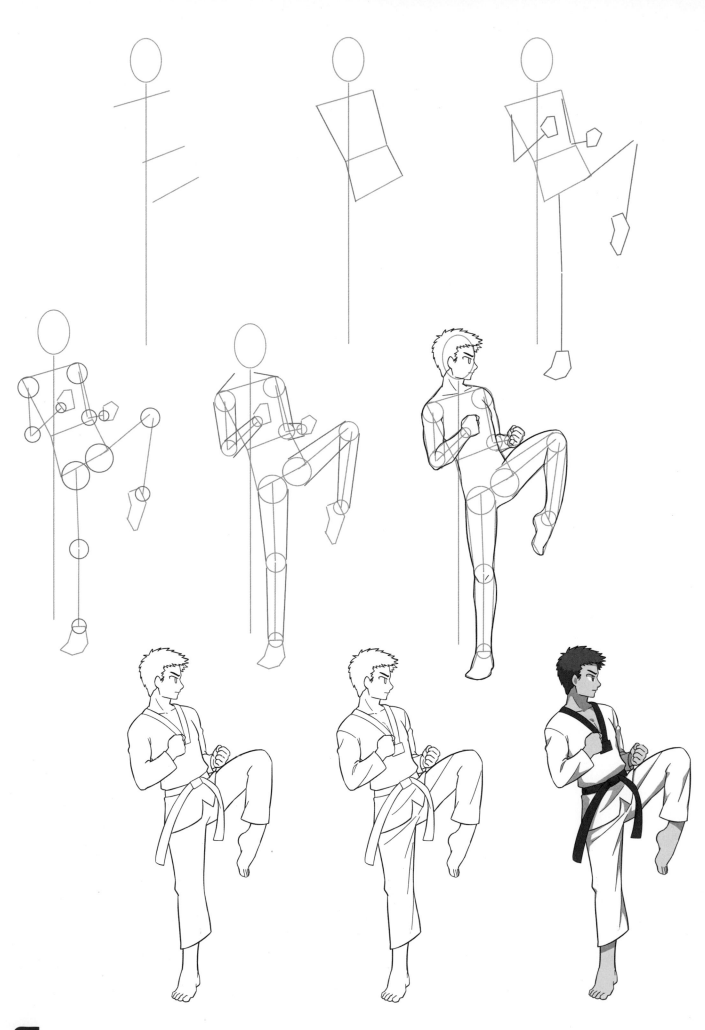

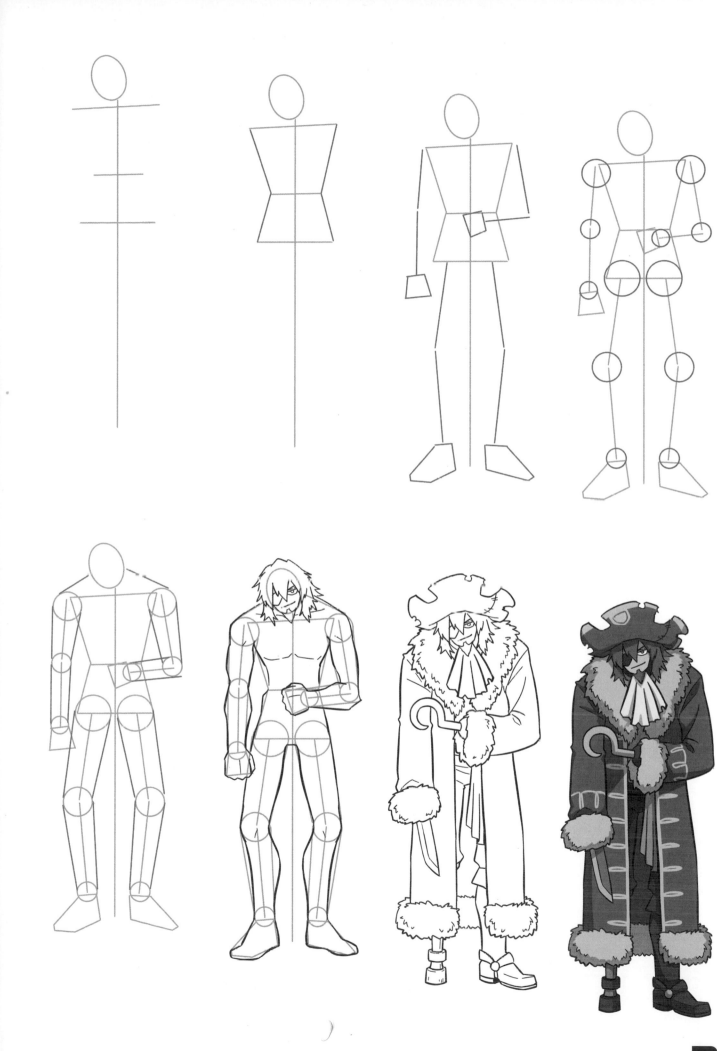

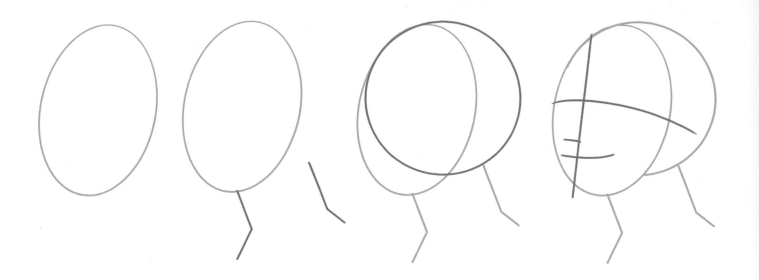

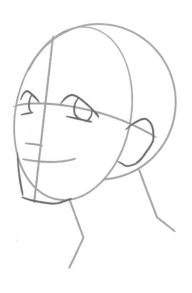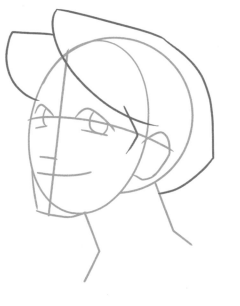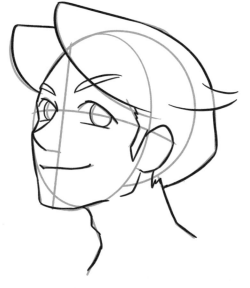

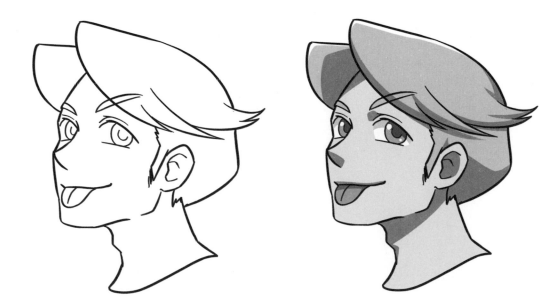

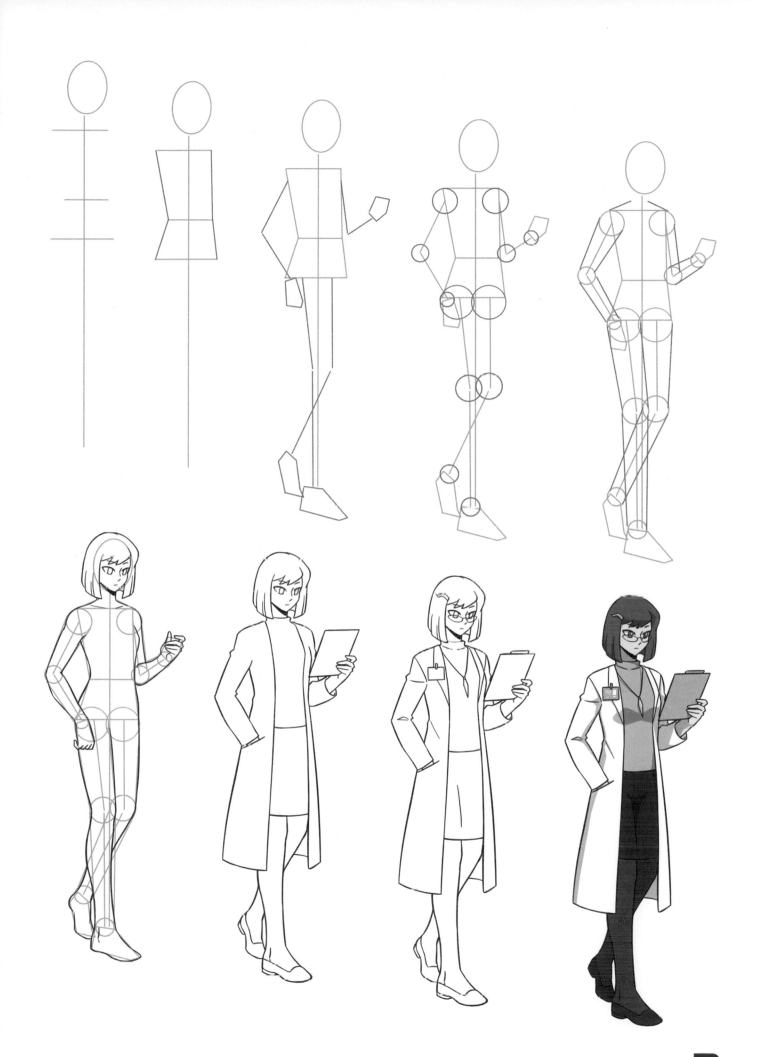

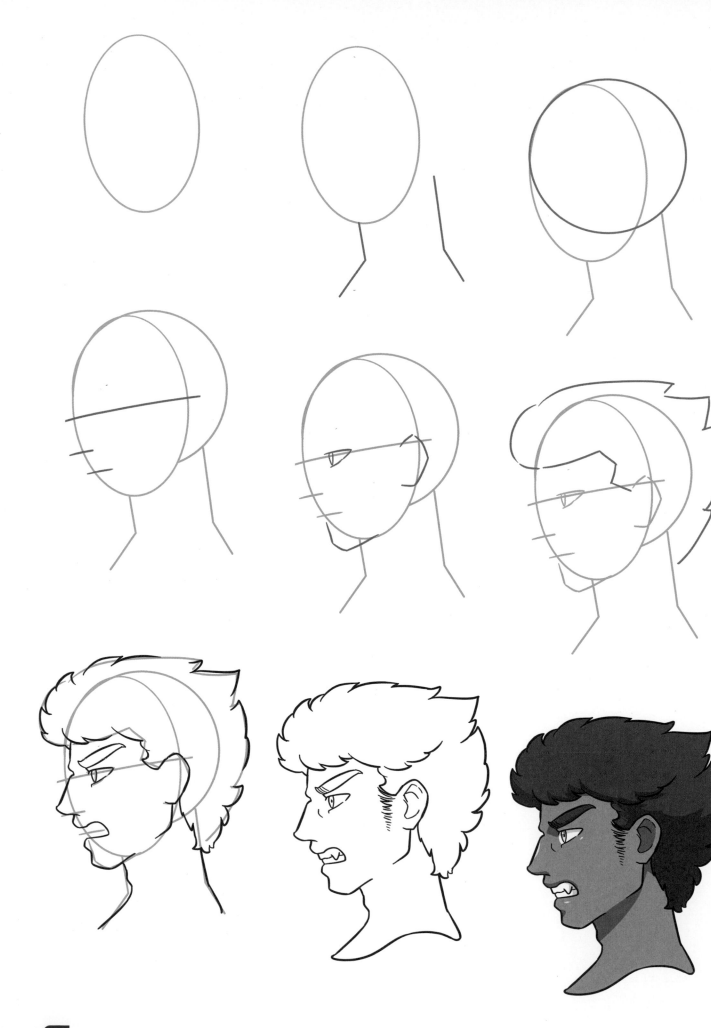

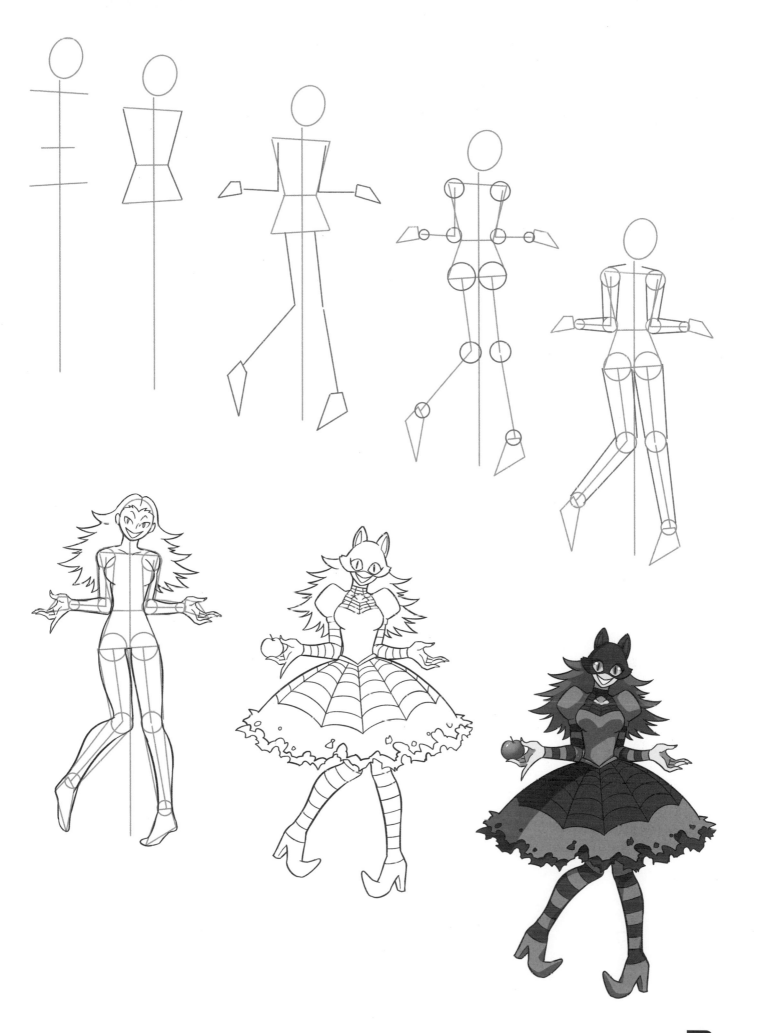

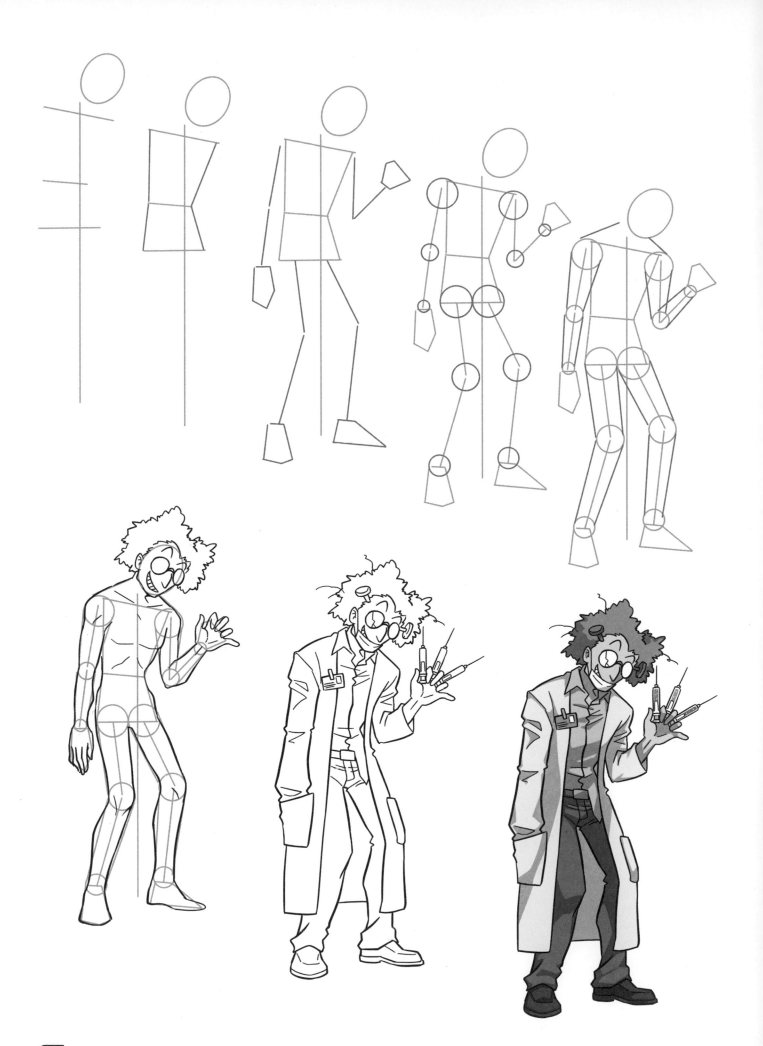

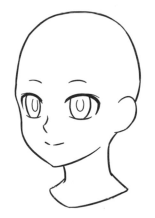
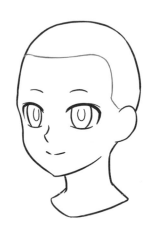
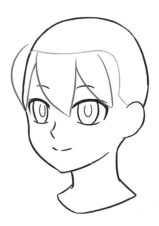
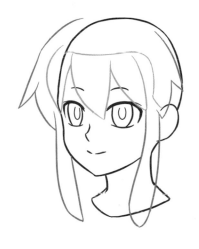
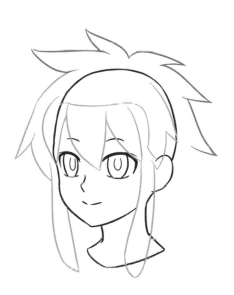
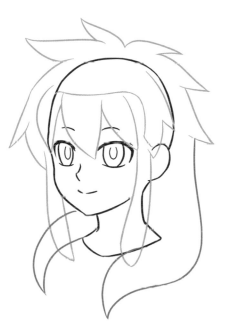
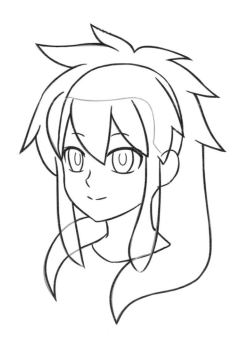
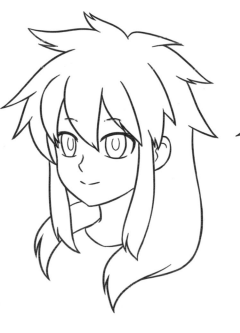
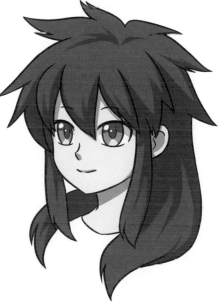

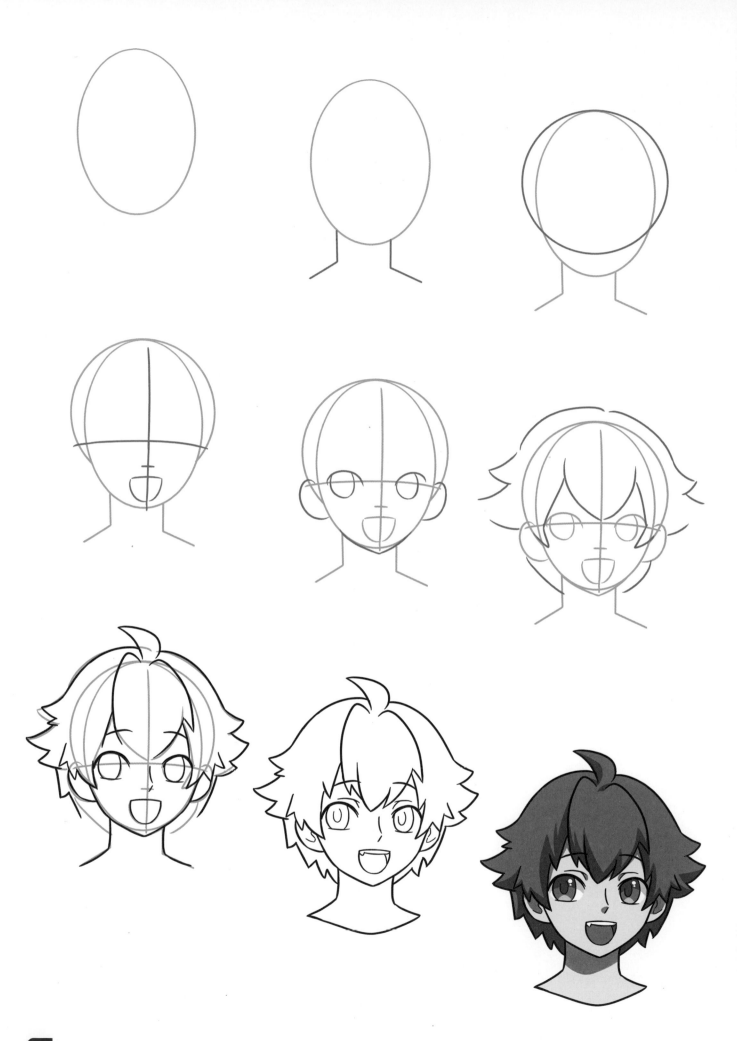

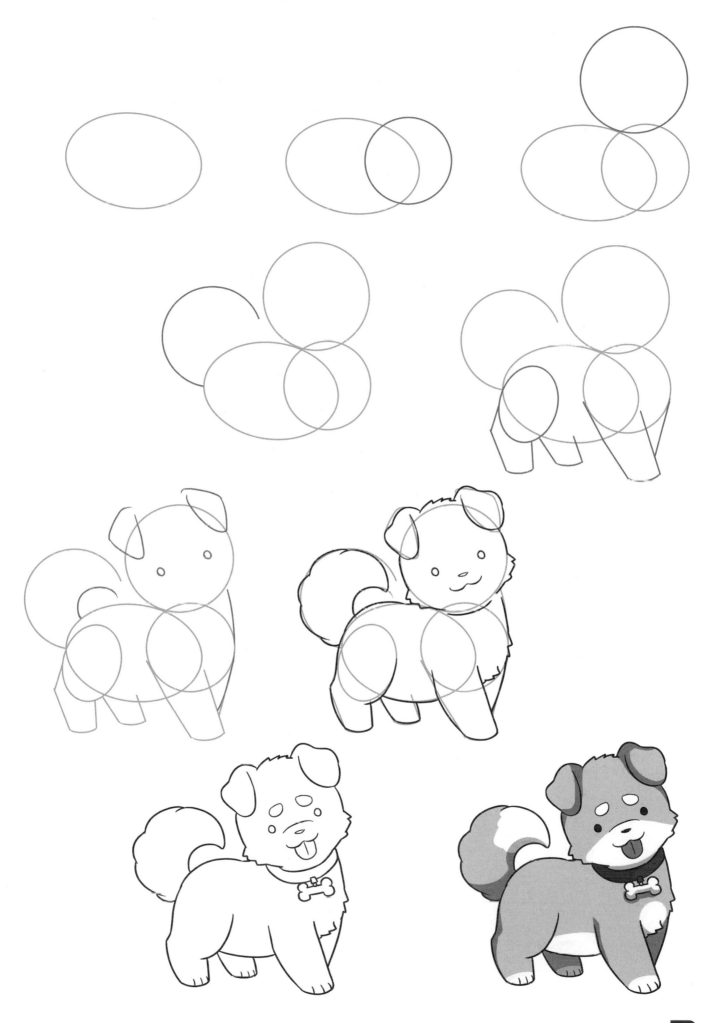

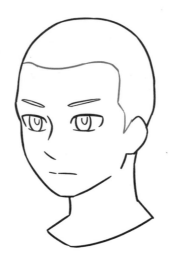
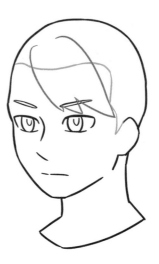

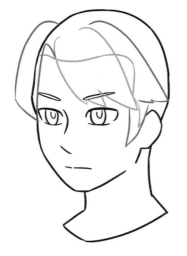
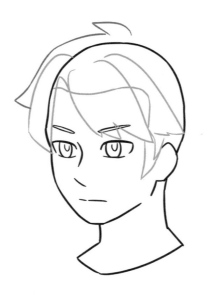
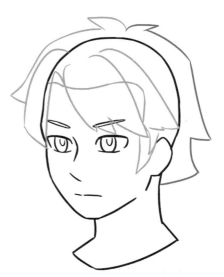

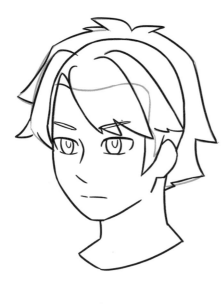
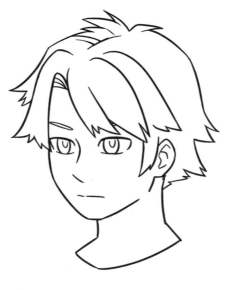
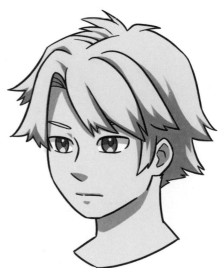

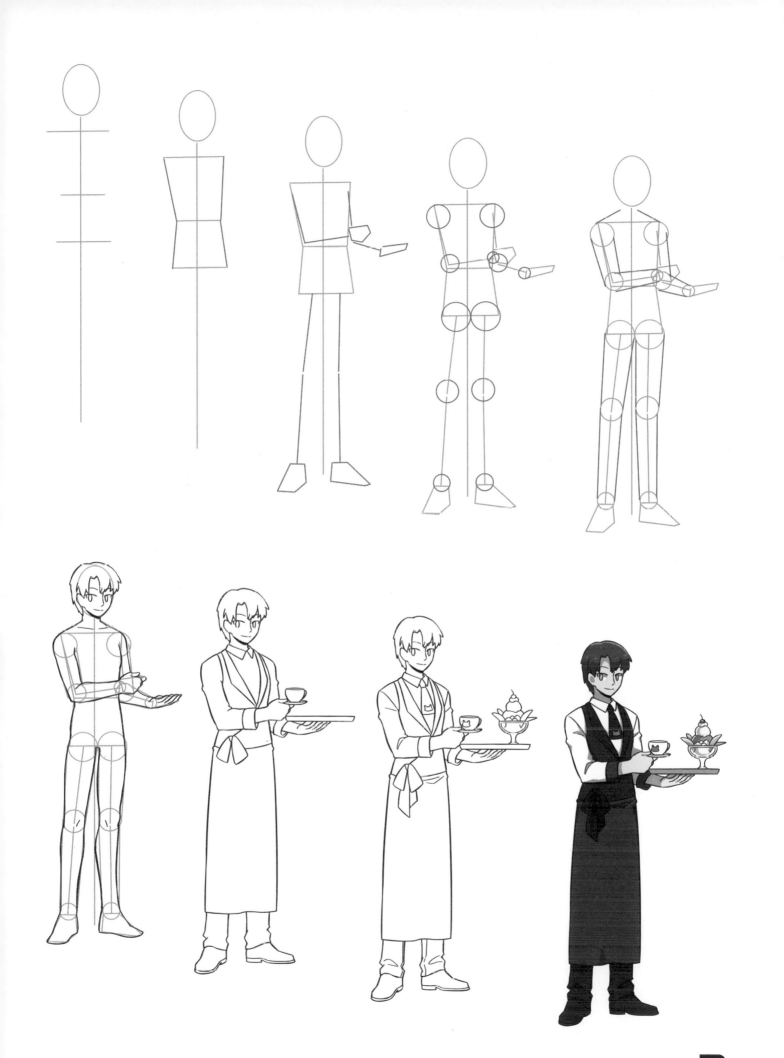

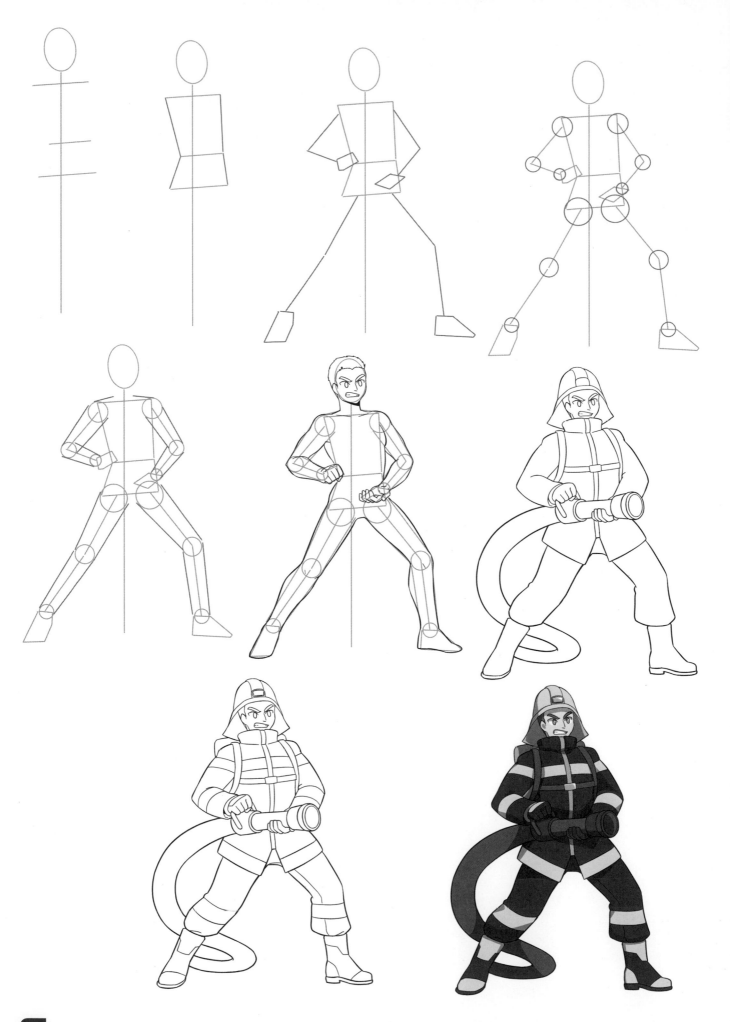

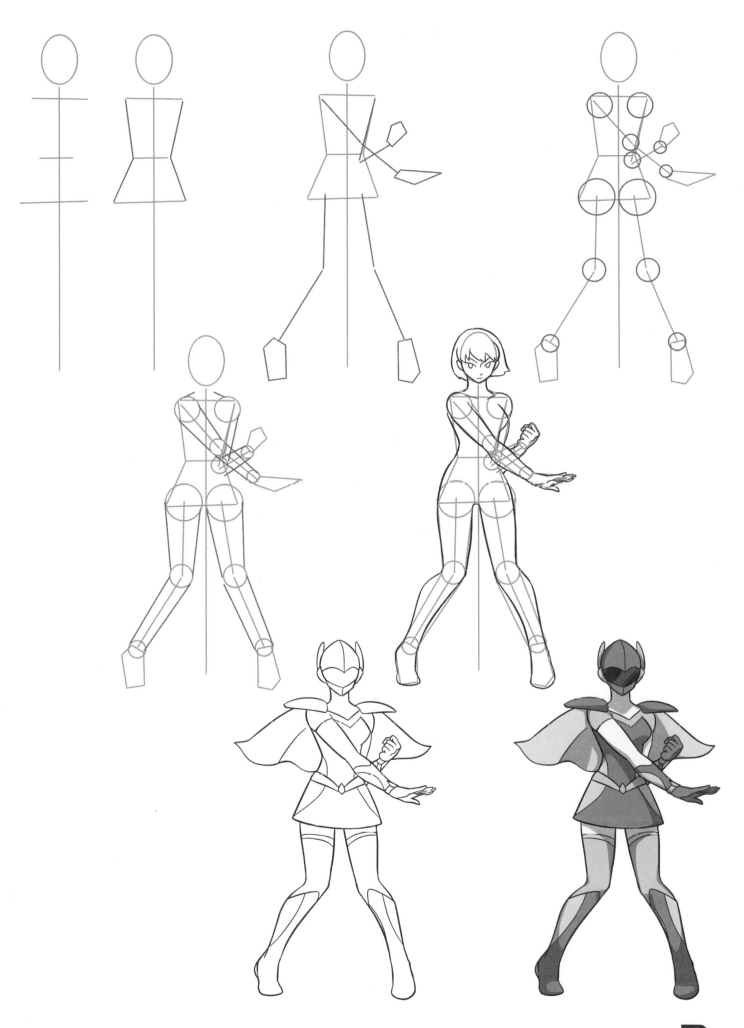

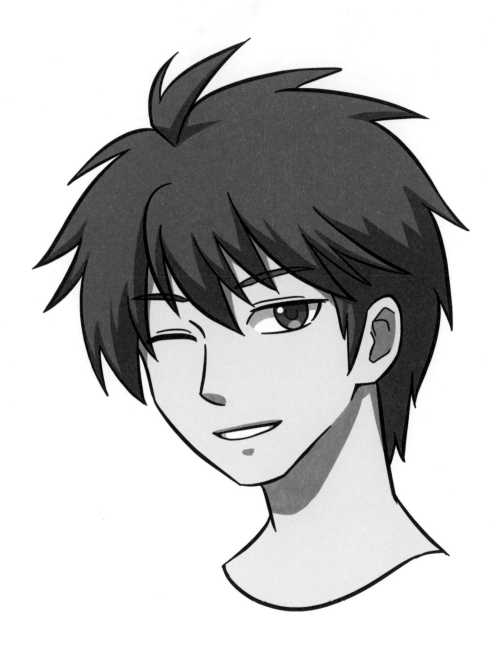